Wisdom

Andrew Zuckerman

Ideas

PQ Blackwell in association with
Abrams, New York

Wisdom

Andrew Zuckerman

Edited by Alex Vlack

Ideas

Nothing excites me more than being inspired by a new creative idea.

Robert Redford

Far more interesting than problem solving is problem creation.

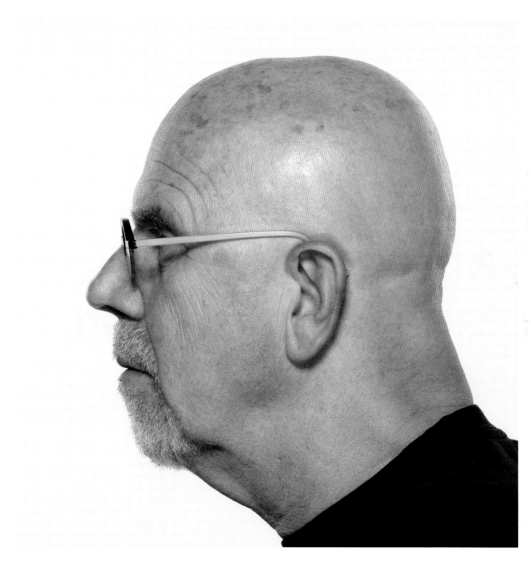

The advice I like to give young artists, or really anybody who'll listen to me, is not to wait around for inspiration. Inspiration is for amateurs; the rest of us just show up and get to work. If you wait around for the clouds to part and a bolt of lightning to strike you in the brain, you are not going to make an awful lot of work. All the best ideas come out of the process; they come out of the work itself. Things occur to you. If you're sitting around trying to dream up a great art idea, you can sit there a long time before anything happens. But if you just get to work, something will occur to you and something else will occur to you and something else that you reject will push you in another direction. Inspiration is absolutely unnecessary and somehow deceptive. You feel like you need this great idea before you can get down to work, and I find that's almost never the case.

Something happens when you have inserted rocks in your shoes. Before I was physically disabled, I was learning disabled, so I've always had problems. Problems limit certain things, but they also open other doors. I've thought that for a long time: the choice not to do something was in some ways more important and more interesting than the choice to do something. We may not know what we want to do, but we sure as hell know what we don't want to do. So you construct a series of self-imposed limitations that will guarantee that you cannot do what you no longer want to do, and then that kicks open a door; and if you're willing to go through that door and follow wherever that leads, you will have programed change. Now you are doing something else; you compare that to what you were doing, like it better, you think it's more interesting,

you stick with it, maybe alter another variable, then alter another variable. If you don't like the direction it's going, you stop, aim in another direction, and move on. The artist who influenced me the most was Ad Reinhardt, because he made the choice not to do something a positive decision. It seems like negation and nihilistic—so negative—to proceed that way, but he made huge lists of things that you can't do any more and it became clear that this was a very good modus operandi for an artist, that through limitations you will push yourself somewhere you could never have otherwise imagined being. I've never had a painter's block in forty-more-plus years, because there's always another limitation, there's always another door to open, there's always another tangent to go off on. I have lots of time to think about that while I'm working, because paintings take four months to twelve months, so I usually have another issue, another problem, another thing I want to solve. I think we're way too hung up on problem solving. The whole notion of problem solving means there has to be agreement on what the problem is, and that's the conventional wisdom: that at this moment these are the problems to be solved. Your solution is going to be almost identical to someone else's solution because the problem almost presupposes what the solution will be. Far more interesting than problem solving is problem creation. How do you back yourself into a corner where nobody else's answers are applicable, where nothing else fits? If you ask yourself an interesting enough question, your solution will, by nature, be personal. You'll purge your studio of all those other people who've been lurking around in there and kick your influences out of the space,

like some sort of cultural exorcism, and find yourself left with your own problem and the struggle to find the appropriate solution.

I really never understood the argument of why make a painting or why make a photograph. They're just so different. A painting doesn't happen the same way a photograph happens. A photograph is all over at once. It's a continuous surface. You can go back in and alter it, but basically it all comes up at once. When a painting happens, it's always unfinished before it's finished: you get a chance to see what you just put in, how that affects what's already there, and how it anticipates what else is going to happen. You have this long dance, this long performance. A painter is really a performing artist; it's just no one watches the performance. The painting is the frozen evidence that this ritual dance or performance took place. We're moving our arms and we're building this thing out of thin air with colored dirt on a cloth wrapped around some sticks of wood and it's the most magical of mediums, the most transcendent. It transcends its physical reality. It doesn't remain just colored dirt on a flat surface, it makes space where there is no space, it reminds you of life experiences you've had, it transports you somewhere else. A painting can make you cry, and it also can bring you great pleasure. I love the magic, I love the alchemy of taking this colored dirt and smearing it around with a stick with hairs on the end of it until you conjure up some kind of illusion or some magic. I like to leave evidence of the trip taken. I'm like Hansel and Gretel, dropping crumbs on a trail: not only do you have the image I made for you, I'll show you how I made that image. I don't

want to destroy the magic; I want to pull a rabbit out of a hat and have everybody go, "Ooh,"—then I'll slow the whole thing down again and I'll show you how I pull a rabbit out of the hat. And because photography has no incident, no hands, no touch, no physicality, it's really ethereal; there's no evidence of the road taken, you have no shared experience with the artist of taking this trip, this route some place. I love photography, it's really the only thing I collect and of course I am a photographer as well. But there's no question that painting is of a different order. It's a different kind of experience and it's one that I really enjoy making and enjoy showing to other people. And it's interesting: once you know what art looks like, it's not hard to make some of it. But if you're going to be a painter, you are going to make a lot of really bad paintings before you ever make a good one. With photography and video it's possible to have an accidental masterpiece. Let me tell you, that is not possible with painting. Some amateur is not going to accidentally make an incredible masterpiece. There are other kinds of things going on than just framing a chunk of the world and lighting it and snapping a shot.

A person's face is a kind of road map of the life that they've led. There's no reason to crank up a portrait for greater impact, by increasing the content in a dramatic way. I never wanted people to be laughing or crying. Just present them neutrally: straightforward, flat-footed—boom—like a mug shot. The information the police want to have is essentially the information I want to have: just what's there. What I've found is that without amplifying anything or increasing the emotional content particularly, there's all this

information embedded in the face itself. If you've laughed your whole life you have laugh lines, if you've frowned your whole life you have furrows in your brow. Sometimes you have both, and most people have a kind of duality of life experience, some tragedy and some great moments of extreme happiness, and I don't want one of those to overwhelm the other. I would like to just present the information. We make decisions about people in a portrait largely the same way we do when we meet them in real life: size them up, get a sense of whether or not they're engaged with you and whether or not they seem to be comfortable with themselves. So that's been my approach: a passport photo or police mug shot view of the other world, and I've been able to get pretty much the complete range of experiences into the work. I get rid of everything else, get rid of the background and everything. I did a portrait, a fingerprint portrait of my wife's grandmother, who was a Holocaust survivor. I think eight or nine brothers and sisters and mothers and fathers and everybody except her and one maiden aunt, who got out at the end of the First World War, were killed by Hitler. But she remained. At the same time as she embodied incredible pain and loss, and survived her guilt, she was also the most optimistic person I've ever known and it was really interesting to see how her portrait embodied that extreme range of experience, from the most unbelievable heartbreaking tragedy to incredible pleasure and happiness and fulfillment. I made it with my own fingerprints, and Rob Storr, when he did my retrospective at the Museum of Modern Art, said that I was making skin with skin. (I thought I was making something that couldn't be forged.) The other aspect that he said was that it was like I was caressing the face of the subject while I was making it. And I thought, well, you know, that's really pretty much what it's about.

I don't think anyone would accuse me of making beautiful portraits or portraits of beautiful people. I don't do movie stars. I don't do supermodels or anything. I don't try to make people look ugly or grotesque or anything else; and I try to be as ruthless with myself as I am with everyone else, so I show all my own wrinkles and zits and whatever. Because that's more interesting to paint. I tried to paint babies and there's nothing there yet: nothing's happened, nothing's sagged, nothing is wrinkled up—it's just a blank. So my subjects are usually of a certain age, where there's some wear and tear and you know that they've been around the block and they've had some experiences that make them—I guess the equivalent of a character actor as opposed to an ingénue.

Embedded in the work itself is the criteria for judgment. You can glean from looking at a work of art what the intentions of the artist were. There's no sense in judging it with a yardstick that's not appropriate to what the artist was trying to do. I'm a big believer in intentionalist criticism: what did the guy want to do and did he do it? You can glean from the work of art itself what the issues are, try and figure out what he or she was trying to do and whether or not it succeeded.

It's much easier to be an artist where people think the making of art is a good thing and where other

practitioners are around. I make work for other people to look at. I don't do it for therapy; I go to therapy for therapy. I love what I do, and no one enjoys what he or she does every day more than I do. I love to paint. But if I were on a desert island, I would not be one of those artists who poked a hole in his arm with a stick and drew in blood on the back of a leaf. If there's nobody there to look at it, I don't think I'm going to make it. So the community is really an essential ingredient; and the fact that New York is a big community with lots of artists and artists of all persuasions— it's just a bigger sandbox to play in. It's much more interesting. I always found it very difficult to work where nobody thought that activity was particularly important. I have a studio in Long Island and I love working there and I love going to the beach, but I realized it's very hard to work where everybody else is playing. Working in New York, the energy of the city, everybody moving fast and schlepping stuff and hauling stuff and tearing things down and building things up…if you're not working, you feel unbelievably lazy, as if you are not contributing in any way to the mix of ideas and issues.

Now that my children are grown and in another house, I work essentially three hundred and sixty-five days of the year. I work Christmas Eve, Christmas Day, New Year's Eve, New Year's Day—doesn't make any difference. Any day that you just do a little something, all those little pieces of something add up and it continues the momentum. You don't sit in the studio after not having been in there for several days thinking, "Oh my God, now what was I doing, where was I, what's happening?" It's really, really important to keep continuity and keep momentum going.

Dick Bruna

If you put very few things on a page, you leave lots of room for the imagination.

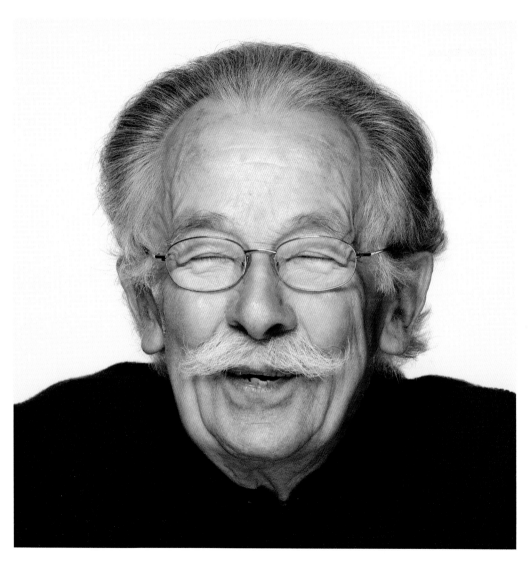

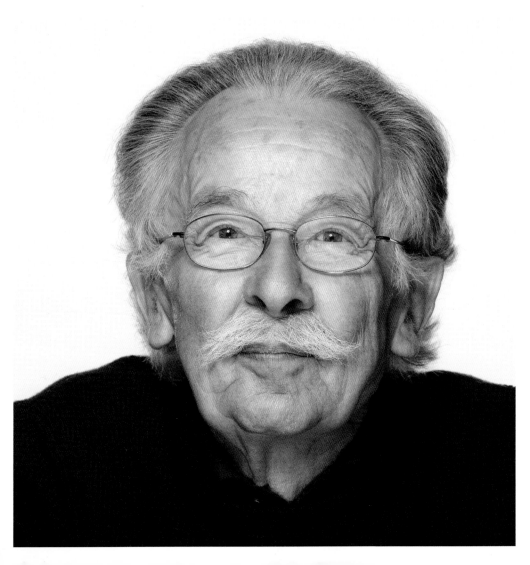

I draw every day. Seven days a week. I always go to my atelier. I like that very much. I've always done that. It's important to make your art every day.

I always work on my own. I don't even talk about my work. My wife doesn't even know what I'm doing. I work, sometimes for a month, and when it's finished, she's the first one who sees it. I show it to her, and she is a very good critic. I see it in her face. It is just like taking an exam or something. Her face reveals a "yes" or a "no." If it's a "no," I think, "I have to keep working on that." I need a very good critic, because when you're working alone every day, you don't see your mistakes.

I work with images first. I've always drawn, even as a little child, and I did lots of drawings for book covers over the years. One day I had the idea that it would be nice to not only do the cover of a book, but to do a whole book. The very first book I did became a children's book, but I more or less did it for myself, to make a book that I would like to have. It's how it started. It's amazing that I've done over a hundred books now, and I still feel it's just as difficult as I found it fifty years ago. Even more difficult, I think, because today I like to do it a little bit better than yesterday.

Dave Brubeck

What you hope to be in is complete, total concentration, and that is hard to get.

Sometimes they put a spotlight on you and it's like a train light coming down the track. I close my eyes at that point, but just the fact that you've got to think about closing your eyes to get rid of what's distracting you…the sound of the PA system, the sound of the piano, all these things bring about whether you're going to have total concentration. And that's what I'm always looking for, that concentration. When it hits, it's great. You go into new territory, where you've never been before, if you're in what we call "the zone."

You're constantly picking things up and developing things from your group. My old alto saxophonist, the great Paul Desmond, would say that he thought we had ESP, because one night we both made the same mistake, which really frightened both of us because we're used to covering a mistake. And, in fact, there's a great example of him covering a mistake when we recorded with the New York Philharmonic with Bernstein conducting. The trombonist hit what should have been a B flat, but he didn't notice the flat in front of the B and he hit a B natural. Paul was improvising and brought that right into the improvisation, immediately, and it's so beautiful; I always say that there's no mistake if you can resolve it, whether it's in your music or in your life. Sometimes the mistake motivates you or elevates you into a different circumstance that can be better. If I make a mistake, I'm going to develop that mistake, so it doesn't sound like a mistake.

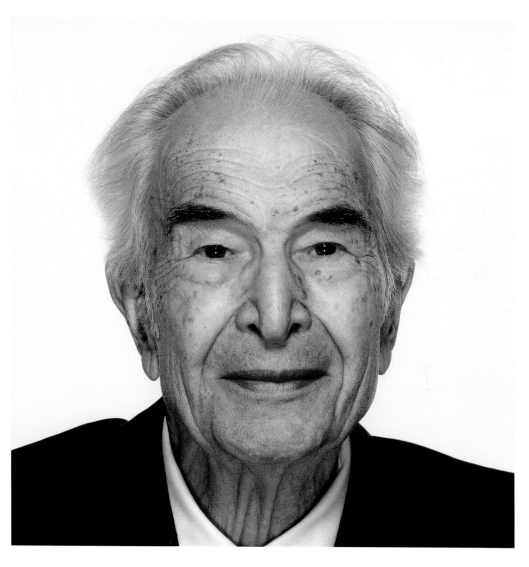

David Amram

You move right along that path and stay on that path, whatever happens. You're aware of your surroundings.

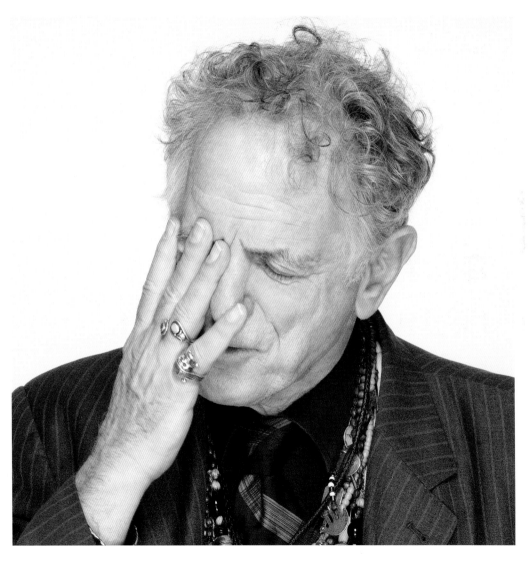

Miles Davis says there are no wrong notes in jazz. By that he did not mean to play anything—he had the most beautiful selection of notes imaginable. But he meant anything that you have can move to something else if you have a right path. When I was playing with Charles Mingus, I was a twenty-four-year-old hayseed in New York City playing with these giants; I was in the middle of playing my French horn and the cash register went bo-la-la-binka-ding. And I got confused. Mingus said, "Come on, man, don't pay any mind to that cash register." He said, "Next time that happens, play off the cash register." I said, "What?" He said, "Use that as part of the music. If you're playing, the piano player is going blockity-block, the drum is going buckita-bucka-ding. Put that into the music and answer it. Go bita-boo-boo-bum and answer the cash register. Make that part of the whole experience." Thelonious Monk had a song called "Straight, No Chaser." The same idea. You move right along that path and stay on that path, whatever happens. You're aware of your surroundings. Every person is, at that moment, a part of the situation, and you incorporate and tune yourself into that. And when you do that, not just in jazz but in anything, including family life, you can't go wrong. Because anything that seems to steer you off the path is only a different alternate version of MapQuest that might even be better than the MapQuest we're told we're supposed to follow in life.

Less is more, or, as we would say, when in doubt, leave it out. That's the hardest thing to do: to know what to do and what not to do and when to stop

without overdoing it. The second part of that equation is that if a composition is well enough structured, and you use a few things and develop those well and have a beginning, a middle, and an end that is clear, the people who are then doing that will be able to express themselves and put their feeling into what's there and it will be something that will reach and move an audience. That's what great playwrights do. That's what I learned from writing music for Shakespeare in the Park for twelve years, or working with the great Arthur Miller when I did music for his plays: that the play was so strong that actors taking that beautiful architecture could make it their own, and it would come out to be something just terrific.

We can all go back to the very roots of music: the heartbeat, the song that every person has in their heart. The ancestral psychic memories, DNA, genetic memories, whatever it is—I would never claim to understand it—it's there and all those musics express that, paint that picture. It takes you to a place in time and a place on Earth that you've never been before, without even knowing it. I was in the Khyber Pass and I played with the people there, and when I brought those flutes back and I could play that music, people said they could see that. Conversely, when I was in Pakistan and I played "Red River Valley," a woman came up and she said, "I could see your beautiful country when I heard that." When I would play my Native American flute and play a Lakota song that I learned from Floyd "Red Crow" Westerman, people would say, "We could see your Indian people, what they were really like." When you play Mozart and it's done

really, really well, you can imagine you're in some castle, drinking Riesling wine, wearing a white powdered wig. Now, we don't have castles, we don't have the white powdered wig (though we still have the Riesling wine). But you can be sitting in a suburb in Detroit and hear that music and it takes you to that place that Mozart was at. In addition to being such beautiful music in a pure sense, it captures some kind of a spirit of a time and a place. I think that all art does that. You can read Dostoevsky in English and imagine what it was like to be there. You can read Homer's *Iliad* and the *Odyssey* and be out on that ship at sea all those years ago and see those places.

It's something that's a mystery that I wouldn't claim to understand. But musics that survive, over periods of time, survive because beautiful people don't want to let them go and they somehow hand that down from generation to generation. As Odetta said, "Folk music is the root of the tree," and folk music is music of all the folks in the world. It's not only singer/songwriters with guitars; there's all other kinds of folk music from Africa and Asia, and all the people who have come from countries no longer on the map who now live in the United States and for two or three generations have preserved some of their precious music. And it's all beautiful and it's all enriching and every time you play with somebody, you could suddenly, somehow, become part of their world if you could figure out a way just to do your little part to add something to it. Not to take over and hog it, but just to be a little part, like you're being welcomed into someone's home.

I don't ever think about conformism. My idea was never to be a non-conformist; it was only to try to add something to what was considered to be part of the picture. When Bernstein chose me as the first composer-in-residence with the New York Philharmonic, I was interviewed and I mentioned that Fletcher Henderson and King Oliver, Louis Armstrong and Charlie Parker, Lester Young and Dizzy Gillespie, and Thelonious Monk and the great Latin musicians like Tito Puente that I knew, and the wonderful country singers and the Cajun and bluegrass people and Middle Eastern and African musicians were as big an influence as Brahms and Beethoven and Berlioz and Mozart, and that I loved all of them, and to me they were all part of the music, people thought I either had a career death wish, was a schizophrenic, or confused. And I said, "No, there is a commonality of all those great musics." And if I had to have an epitaph, I would say, "Purity of intent and an exquisite choice of notes." And that, to me, is what all great music is about and if you conform, so to speak, to that principle and really want to do the best that you can do and you're really sure that every single note that you play or compose is the best one possible, chances are you might come up with something wonderful. And not to have your mind confused by what's supposed to be trendy—because today's trend ends up in tomorrow's landfill—but rather what is pure, what is in your heart. Everyone has a song and a story and something to express, visually, dramatically, sonically. In a literary way, everyone has something to contribute that comes from them, and if you do that and you develop your skills, chances are you'll come up with something that might be pretty good.

I'm not going to say, "I will not use the English language." I have no fight with any language. I will use whatever is useful to me.

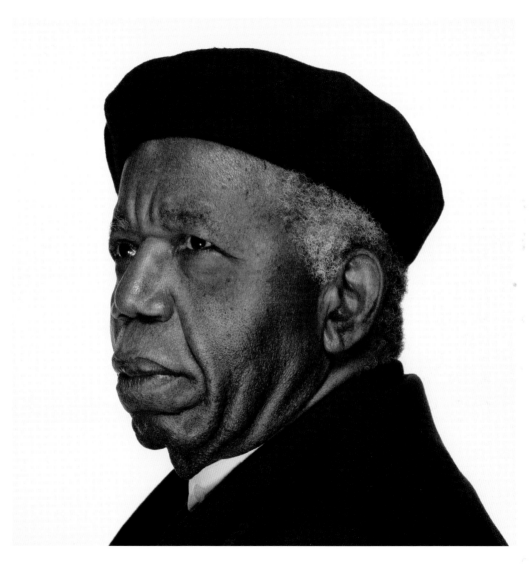

Nobody can tea

ch me who I am.

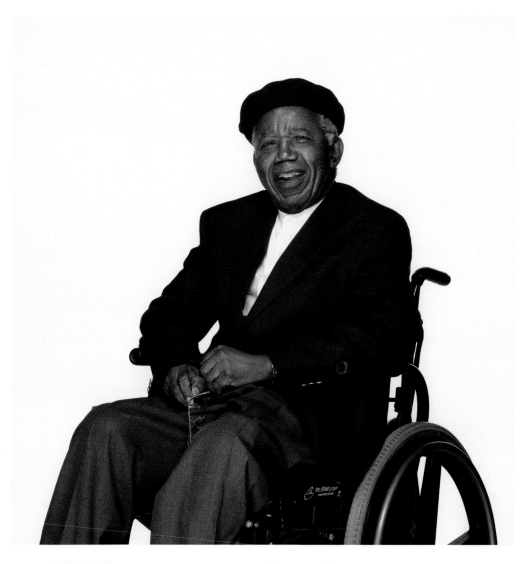

Every tradition has something another tradition can use. Everywhere. When younger Nigerians who think they are going to be writers say, "Look, you are very lucky, there were things to write about then. Today there's nothing," I say, "That's not true, there's no time when there is nothing to write. You haven't found it. Or maybe you haven't looked hard enough." The same way every culture has something to offer, if we are ready to look at it on its own terms and with a certain humility, we will find something we can use. That's the way I have gone about it: using what is made available to me. Saying, for instance, "The old English novel is something that the English created, why should I use it?" "Why not?" is what I say. This is what I spent years of my childhood, into adulthood, learning. I didn't ask to be given an English education, but I've got it and now that I've got it, I might as well use it. I'm not going to say, "I will not use the English language." I have no fight with any language. I will use whatever is useful to me.

If you're grabbed by art, I think you should do whatever comes best to you. Whether it's a novel or a play or a song, it doesn't matter as much as the fact that you are doing something about the situation. I can't explain to you why fiction, why prose, except that that's how it came to me. The way the work imposes itself on you is part of its power, and you respect it or you fight with it all your life. So I found the novel form and it seemed to me to work. The first attempt I made when I was a student in the University College of Ibadan, I was told by my teachers from England, "This is a good piece of work, but it lacks form." And so I said, "Okay, what's form? Can you tell me what form is?" And the lecturer said, "All right, we'll talk about it next week. I'm going to play tennis now." So we didn't talk about it next week, we didn't talk about it next month. Long afterwards she came to me and said, "You know, I looked at your story and I think it's all right." So I never learned what form was. Actually, she had nothing to teach me, it was a kind of instruction to me that this is something you have to do on your own. Nobody can teach me who I am. You can describe parts of me, but who I am and what I need, these are things I have to find out myself.

Nadine Gordimer

Writing is a discovery.

I've been writing since I was eleven years old. And I am really an autodidact. I've had a very poor education. I've got these honorary degrees but I haven't got a university degree that I worked for. My education has been the library and books. And, of course, curiosity and the desire for knowledge, not just in literature, but generally. That comes to someone who's going to be a writer. I hate to say this, because it's discouraging perhaps for some young people who are looking for a quick fix. But creative writing classes...I once did one in America, and then I thought: "What you're doing is false." And I've never done it again. Because if you're going to be a writer, it's like if you're going to be an opera singer. An opera singer, I'm sure, is born with special vocal chords. What I haven't got, and I'm sure you probably haven't got. I can sing in the bath and that's about all. And you could have many singing lessons, for the rest of your life, and you will never be an opera singer. Now, you will never be a writer unless you are born with certain qualities. I could name a few. First of all, you have to have a very inquiring mind. You have to be extremely observant and alert, so that whether you're in a bus and you overhear a snatch of conversation or you're in a queue and somebody has certain bodily gestures, you learn to read what people are. You learn when they speak. If you hear people having a quarrel, you learn to supply what is going unsaid. Of course, it comes along with your own experience of life. But you have to have this extreme alertness; you have your ears wide open and your eyes wide open, from being a small child…then you're going to be a writer.

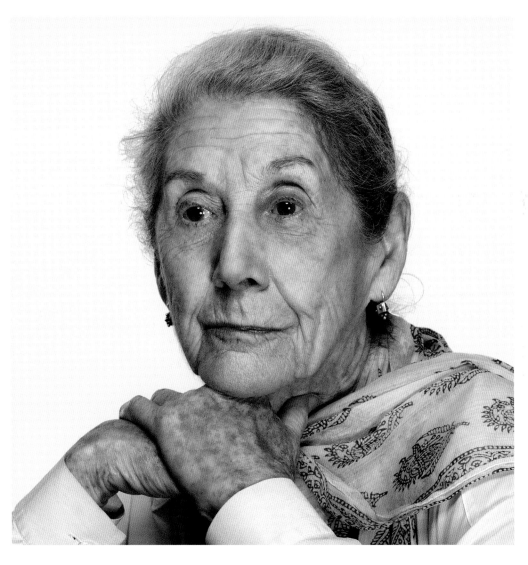

When I am painting, everything is in my mind. I don't think anyone can tell me what to do. When I start painting, everything just comes.

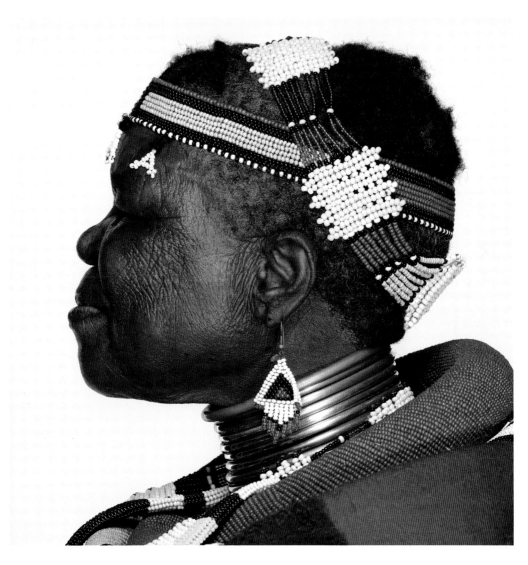

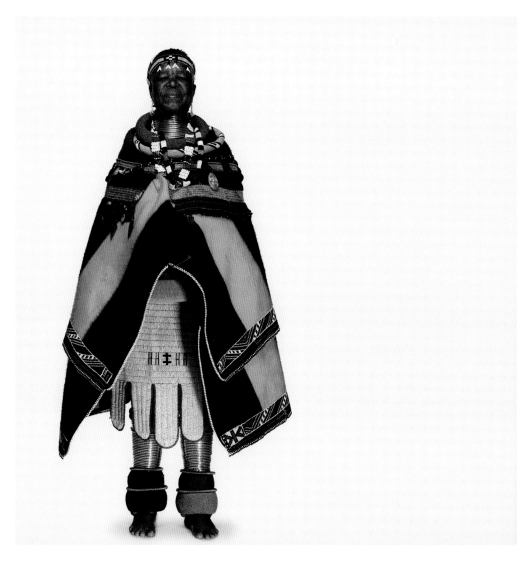

When I begin to do something, I know where to start and how to do it. We used to see our forefathers and grandmothers doing it, and then we learned from that and memorized it. Whatever we learned stayed in our minds forever.

Students of painting must not be misled by people who say to quit because painting is useless. If you like it, then do it for your personal development.

Kurt Masur

Education can sometimes prevent you from discovering yourself.

My beginning as a musician was at least at the age of five, because I was very often alone: my mother was working, my sisters were in school, my father was working. There was a piano, and I started to play some children's tunes. I tried to play and I played better and better and better. And somebody discovered suddenly that I had musical talent. It was not taught. This is my personal wisdom, because everybody has to find out his personal beliefs. What do you believe? Do you believe in any God? More and more people, if they believe in God, have their own kind of God. They are not so dependent on their confession, they are not so dependent on Buddha.

No conductor is greater than the great composers have been. We are servants. Of course, we should be servants with all our passion. We give the music our stamp. But if you feel that your stamp is more important than the composition, you fail.

When I started as a young conductor, people liked me because I was very friendly. Then, I remember, one of the orchestra musicians who later became my very good friend, came to me and said, "Dear friend, as a conductor, you behave very badly. If we are not playing good enough, you cannot smile. You're always happy. What's the matter?" Then I learned, step-by-step, what musicians expect from a conductor. They expect honesty. In the arts, you cannot lie. You cannot do a kind of diplomatic thing. If I speak to a musician in the orchestra, he should feel that I respect him highly. Otherwise, he wouldn't be willing to follow me. He must feel like a partner.

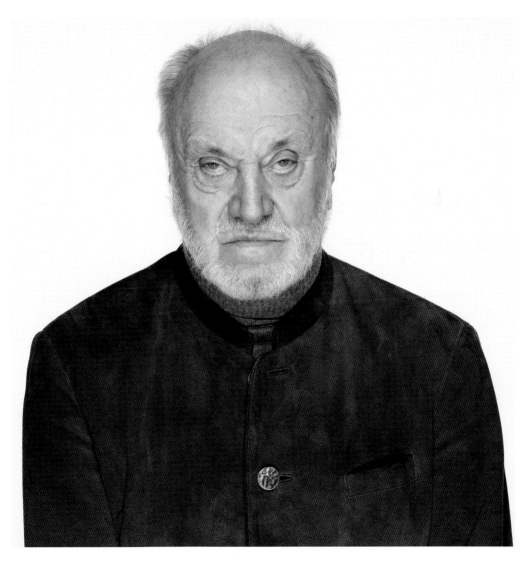

Alan Arkin

Collaboration doesn't work when you hang on to your vision as if it's what God is waiting to hear and learn from. But a good collaboration is when you're willing to sacrifice and throw your own view out for something that's more exciting, more cohesive, or more interesting.

Kris Kristofferson

I just finished working today with Roseanne Cash and Elvis Costello. She'd given me a verse with a melody with hopes that I'd write some of the rest of it. I didn't understand any of the song or any of the part that Elvis wrote either, and I was really worried about whether I was going to be able to come up with anything, or get a handle on what they had. Twenty-four hours before the session, something came that put the whole song together. We spent the whole day working on it today and it turned out beautifully, and I have to think that it just came from being open to whatever would come through me, rather than thinking something up on my own. That's the way I felt with most of my creative work in songwriting: it's come from somewhere else. It's not something I can sit down and write by assignment, or figure out on my own. It's just being open to whatever's coming through.

When I was a child, I was writing songs and making sense out of my experience. Thankfully, that hasn't changed. I imagine there'll come a time when I don't feel as inspired to work as I do, when I'll just sit around and play with the kids. But right now I still get a lot of satisfaction out of being able to create things and to communicate what I'm creating with other people.

I wasn't really attracted to acting at the beginning. I actually started acting at the same time I started performing my own songs, and came to appreciate both of those over the years. I used to feel that the act of creation, of writing songs, was what really inspired me and was my main satisfaction in life, but I came to appreciate the creative part of performing honestly, to be able to move people the same way that I could move them with writing. The same thing that worked for me onstage performing worked in acting: if I could make you believe I was telling the truth then I was succeeding. That amounted to being as honest as you could be with the material you're dealing with, whether you are playing a villain or a nice person. It felt like I was doing something I was meant to be doing and it still feels that way. I hope that it will continue to. But I'm getting pretty old.

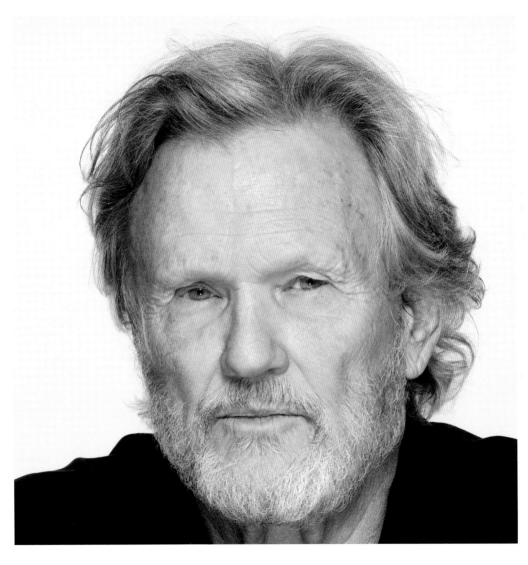

It's not something I can sit down and write by assignment, or figure out on my own. It's just being open to whatever's coming through.

I love collaboration, because I know that people have gone down a path that I've never been down so I'm hungry for their knowledge. Let's compromise, let's negotiate, let's collaborate, let's participate and get the best out of both of us.

Music is an echo—a dead-set echo that goes back to day one in the human race.

Jeanne Moreau

Life feeds art and art feeds life.

There's no "healthy relationship between life and art." There's no "relationship." It's the same—the same energy. Life feeds art and art feeds life. I was born that way. That was always my desire and what I fought for, against any obstacle. And I became what I wanted to become. So it's a way of life. Whatever I do, I feed myself: with any event, any painting, any relationship with people. And being an actress is so rich because I know more and more about what human beings are about. Lots of people think that you are your own instrument, and it's true. And you play with just your own chords. After a while, what stays the same is your body and your face. But at one point there is a sort of intuition that makes you become somebody else, and you give birth to people you wouldn't have met otherwise. It's a discovery. It's a very special exercise.

I have some stage fright, but I have no fear for the judgment of people. I relate everything onstage to the audience; or, when I'm filming, with the technicians and the director. They are the first viewers. Stage fright is born from the ultimate desire to be as close as you can be to what you are supposed to portray. It's not the fear of judgment. It's not: will I be good? Will they like me? I don't give a damn at that moment. I don't think about how to please people. But I wouldn't call it fear. It's a sort of excitement. It's like jumping in water for a fish.

Films can be very powerful. First of all, when you can film what you want, when you can tell the story you want, it means that you live in a free country. In any country dominated by a tyrant, everything is submitted to censorship. And even if it's not submitted to censorship it's very frightening when you feel that people censor themselves before they express themselves, in speaking or in writing or in acting or filming. So thank God it is still a free country. Film has a specific role in society. Otherwise it wouldn't be banned in some countries.

To be a free spirit is provocative. I tell you, I have no money and I don't give a damn. And with the financial crisis, people who were very rich lost the most. I didn't lose much. You see what I mean? As long as I still adore and love what I have to do, I feel safe.

Andrew Wyeth

I find that just sitting, studying an object, or a person, in all positions, keeps me very flexible for my imagination to wander. I get a piece of paper, or a panel, and I start fiddling with it, moving it around. I never know what size it's going to be. It may end up being a postage stamp, or twelve feet long. I don't tie myself down.

A head critic from the *New York Times*, he called me up by phone and said, "Now, Andrew, I'd like to come down and watch you do a painting." I said, "I couldn't do that. It's like you're asking me can I come down when I'm having sex with my wife, making love to my wife. I can't do that. I've got to be flexible." It bothered him greatly. He hung up on me and got another artist.

I don't think relevance is very important. I really don't. At least with me it isn't. I'm sure it is with other people, other artists. But I'm so much in my own world. Talking to you here, I see the quality of your eyes; you've got an amazing expression. That'll stay in my vision a long time. And it may come out. I may be painting a bird looking at me, and I'll think of your eyes. I don't like to tie myself down. That's why I hate commissions. I've done it and it drives me nuts, because they're after one kind of thing, and I don't work that way.

When it snaps, it snaps. To sit down and think up what I ought to be doing, which I've done at times—I hate it. I know one of the best portraits I ever did happened without me knowing it was going to happen. I was sitting in the middle of my studio room and I had this black man standing with me there, and he sat down in front of me and watched my brush, and I felt his head peering down at me. I began to draw the corner of his mouth and the slight smile, and the little bit of dampness of where he had been drinking wine. And I kept drawing and he was more and more interested. And it just happened. All of a sudden, out of this flat piece of paper came this amazing head. It just grew naturally. I didn't tell him to look here, look there. He was just glued to what I was doing. The drawing, the watercolor dry brush, is called "The Drifter." You look it up sometime. You'll see what I mean. It's perfectly natural. I didn't say, "Sit over here." It just happened.

I'm always looking at things and thinking, is that the right position? Does that express the way I feel about this object? It's always in my mind. Even when I go to bed at night I dream about it.

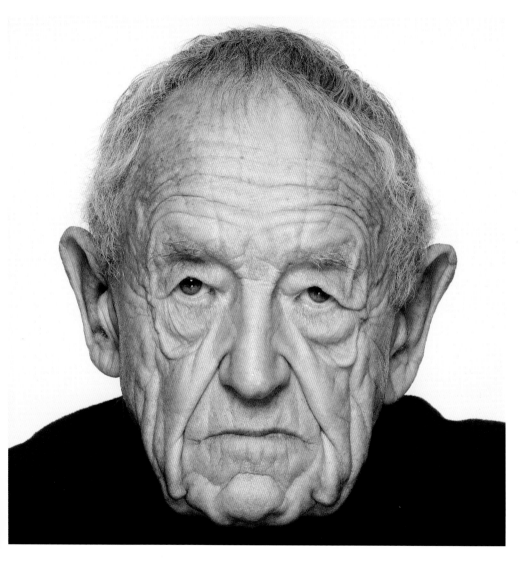

You could go for months and not find a thing that excites you. Inspiration can come from the wind whipping a leaf across in front of you, or across a highway; that'll excite you and get you going. Inspiration is a very, very tricky thing to even talk about because it's such a— it's like making love. Sometimes you can do it, and sometimes you can't.

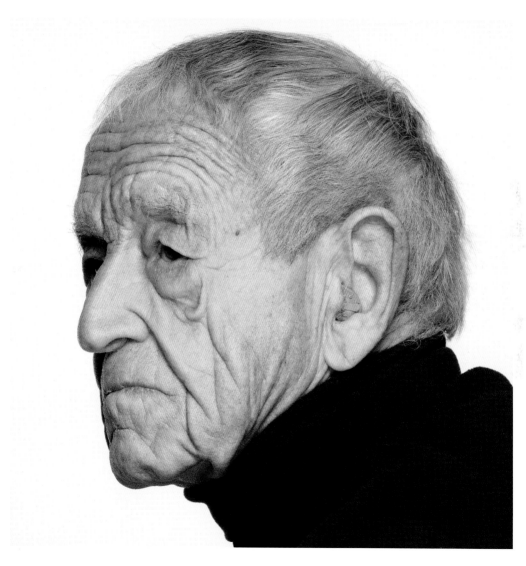

Richard Adams

I don't know where ideas come from. They come from outer space or from God, if you like, or from my subconscious mind. But I never go out self-consciously looking for a story.

Before you start writing, you've got to have the whole story complete in your head. Some people will admit to you that they start writing and they've no idea what's going to happen. I don't believe in that. I think a good craftsman has to have the whole product complete in his head before he puts pen to paper.

The first thing one thinks of, when writing a story, is the audience. And it makes a lot of difference whether you're reading it to an audience of a hundred or just reading it to a little girl. I always try to please whoever is going to listen.

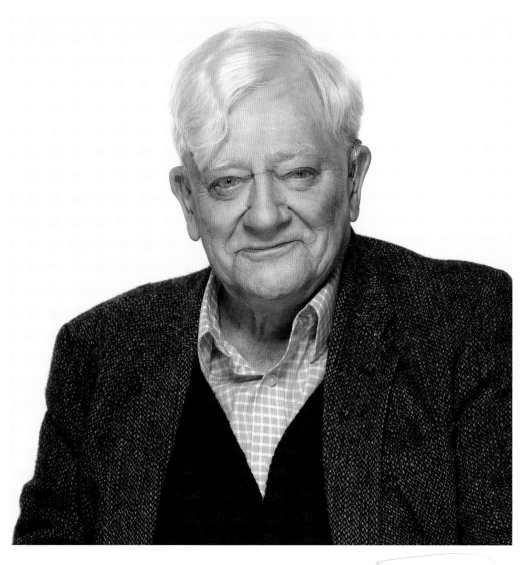

Bryce Courtenay

The moment we were gifted with words, we simultaneously received imagination.

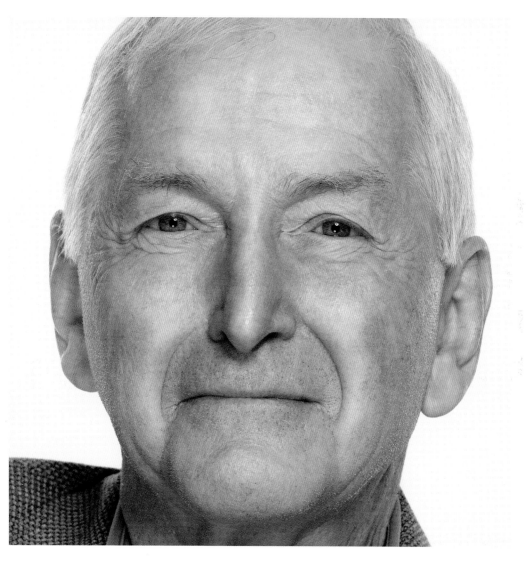

We have to be very careful to define literature because literature's now got a postmodernist dichotomy, which is all absolute bullshit. Great literature, and I wouldn't even pretend to be a contributor to it, is about storytelling. Now, if you think about the story, it is the process of who we are, where we've been and where we're going. It's all it is. It's the longest process that has existed since we stood up on two legs. I have this idea in my head, this vision, and it goes like this: it is primordial times and there is this little extended family and it's a small hill—or koppie as it would be called in Africa, because it's taking place in Africa—and it's overlooking a vast grassland and you can see a blue smudge of mountains at the end. It's at that time in the gloaming when you can't trust the eye, in the evening. This extended family, this primordial family, is sitting around a fire they've built with whitethorn. Whitethorn snaps and crackles like a bullet and it keeps the wild animals away; you hear the snarl of a lion and you hear the noise of the jackal. And the children have eaten round this fire and the children are on their parents' laps, and suddenly a very, very old man comes out of a small cave, walks towards the fire, and you realize there's a jackal kaross that has been left there for him. He's probably thirty years old, he's arthritic and he's bent and he's broken, and he slowly moves onto the kaross and looks out into the desert. You hear wild animals and he says, "This is what happened: the world began." Storyteller. Storyteller. We've been there always, that's what it's all about. It's not about showing off. It's not about clever sentences. It's not about original constructions. It's about continuity, telling the story of our people, telling the story of humankind. Without stories, we are no one. The Xhosa people in Africa have a saying which goes like this: "People are only people because of people." In other words, we don't exist without each other, and our stories are our continuity, whether it be film, whether it be photography, whether it be art, or whether it be words. Now words, in particular, I deal with words. The moment we were gifted with words, we simultaneously received imagination. The moment we could talk and communicate, imagination started. We asked a single question: "What if?" and everything happened from that point on. My job is to write the "what ifs."

My day starts very early. I was always blessed with not needing to sleep a great deal, so I sleep four to five hours a night and always have. I think mostly it was from fear, as a small kid, because I was brought up in a disastrous orphanage where I was the only English-speaking child in amongst the Boers and so sleep was always an anxious time for me. So I learnt not to sleep a lot. So when I say these are my hours, it's because I don't sleep a lot, not because I'm being a brave person. I get up at four-thirty in the morning and I take the dog for a walk in the hills where I live. It's a very quiet place and there are no other people around. I never see anybody. We probably spend an hour and a half in the hills and he'll chase wallabies and get his exercise for the day and I'll think about what I'm going to write about. I'll come back and have a very simple breakfast, probably oatmeal, and then I'll write. I'll write from six, six-thirty in the morning for twelve hours and I won't even get up, not for a cup of tea or anything. It is a period of total concentration, and when the twelve hours are up, bang! A curtain comes down and I don't think a thing about what I've done all day. It's

all over. Then I have a glass of wine, probably very seldom more than one, but sometimes two. I talk to my partner who hasn't seen me since six-thirty in the morning, and we begin another life which is a night life. Then I go to bed at midnight and get up at four-thirty. That's the writing routine.

You have to be very careful about calling yourself a writer. It's such a pretentious idea. We've built an image of these wise people or clever people, mostly clever rather than wise, who write. And that's crap. We're storytellers. We sit on the root of a banyan tree, and kids and everybody else comes around and we tell stories and it's a cop-out, it's easy stuff. We don't have to work hard in the fields; we don't have to poke that bale and dig that row and plant those beans. We're just sitting there talking and I still see that role as being, in a sense, a total cop-out. We got the easy road. So, why do I write? I write as a storyteller, essentially. I don't pretend that I'm going to write the greatest book on Earth. I'm writing for somebody around the base of the banyan tree.

I've got a certain litmus test. If I'm working on something and it keeps me awake at night, and I keep hearing it, that's a good sign.

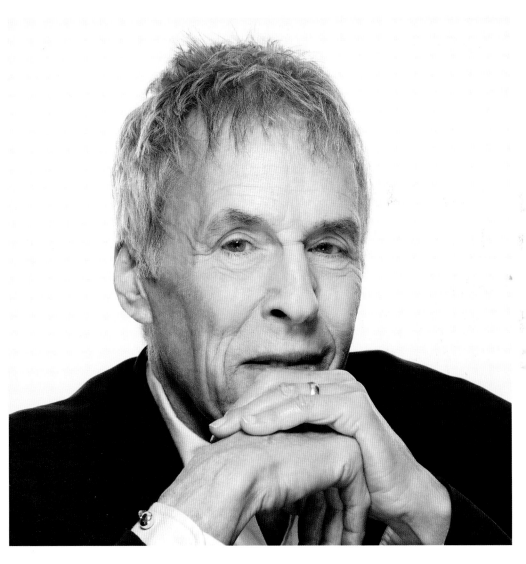

I remember walking by the Hilton Hotel years ago in London and I hadn't done any television yet, I hadn't done any concerts, and hearing the doorman as I walked by whistling "Alfie." He didn't know it was me. When you perform before an audience, then you've got people coming backstage and saying things like, "You know, at this point in my life, I was going through chemotherapy and your music meant a lot to me." If you can move them, that's what I want to do.

Being in touch with your music is very key, very important. I don't think it's so very different than being a tennis player on the circuit. They take three, four weeks off and they'll drop out of the top hundred. Just being in touch with your music every day, because you feed on it and you get used to it. Even if you just improvise, even if you come up with absolutely nothing. I've got two aspects in my life—performing and writing. The performing is really easier than the writing, because I'm performing things that are already written. Performing is a tremendous charge for me now, particularly with symphonies, being out there for two hours playing my music. I see an audience, and I can feel an audience, and I'm making some people feel good or making some people cry. I don't write many up-tempo songs. I write a lot from a very romantic base, romantic core. Where that comes from, I don't know. That's where I'm really comfortable. Maybe I listen to too much Rachmaninoff.

It becomes like a jukebox in my head. It's the orchestrating that I'm doing: what I hear as far as the melody of the song and what is going to surround it, what the drums would play, what the strings would play, the whole orchestra.

I have a funny way of working. I work at the piano and then get away from it. I've got to get away and lie on a couch or sit in a chair and hear the whole thing in my head, so I'm not fooled by pretty chords. There are just so many notes at my disposal and it took me a long time to really get it, that I had some talent in this area.

Darius Milhaud, a great French composer and teacher and kind man, told me once, "Never be embarrassed or ashamed of a melody." That was a big one.

I don't go back and listen to my old records. I get no kick out of that. I can hear the pimples, I can hear the imperfections, I can hear what I might have done. I don't want to go through that because it's done, it's out there. I used to be really terrified of hearing a record that I made, or a song I wrote on the radio, for fear that it wouldn't sound like I thought it should sound—like the way the record was pressed. In the early days, I'd go out to pressing plants and see what they were pressing the record on and whether they were pressing on real cheap garbage stuff. I want it to sound great on the radio. I learned a long time ago that you don't want to get duped with listening on big speakers, hearing it real loud. Being in the studio, you record and then you hear it back and that's why I like to listen at a very low level, mix at a very low level. It's truthful that way. I remember going to Quincy Jones's house when he had the album *The Dude*, and he was going to play it for maybe fifteen, sixteen of us and he played it on a boom box. He didn't play it on all the great equipment in his house, he just played it on a boom box, and it sounded great. If it sounds great there, you know what it's going to sound like when you put it up on big speakers.

When I was working for Marlene Dietrich and I was in Paris at her apartment, she was going to make a record for the German market. That same week, I had at that time the number one song in the United States and the number four song in the United States. It didn't matter. All that mattered was I've got to make these arrangements great. And if they're not great, it's raining on my day. I could have been up at one of those bars just having a couple of drinks and celebrating having two songs in the top five in the United States. I want to hang in there as long as I can hang in.

I want to stay as healthy as I can for as long as I can, just because I don't want to leave. I still feel I have work to do, music to write. If it all stopped now, I'd know I've done well and I should be proud of what I've done, but I want to hang in.

Juan José Linz

In a democracy, it's up to you to participate or not. One of the rights people fortunately have in a democracy is to not be interested in politics, to not care. That may be bad, but they have the freedom to do that. You can vote for candidates who have no chance, but you express your opinion, your preference. The democratic system is more in agreement with human nature and with our notion of freedom and independence than any other.

What's wrong with democracy? Democracy has many inherent defects. First of all, it assumes that there's one single solution to problems and all those other solutions are the wrong ones. Everyone who supports a solution thinks his is the right one and the other one is the wrong one. So, in some ways, half of the people will always be more or less discontent; but they have the chance four years later to convince those which supported one alternative to think it over, to come to their side and do it the other way around. That process, obviously, leads to a considerable amount of unhappiness and a negative opinion about parties and politicians. It's a feeling that *they* do not represent *my* interests. There's a lot of ambiguity in that notion of "representing your interests," because the interests

may be as a citizen living in a certain community which has a factory that is closing, or as a citizen of the whole country, or as a citizen in a world order. In a democracy, people can choose different points of reference and different ways of thinking, and that, obviously, is not the same thing as when you have a classical notion of national interests. In some ways, ethically, democracy creates an air of indifference to the outcomes, within a certain range.

The office of the President is overloaded with expectations. It's a combination of two things. On one side, it represents the whole country, the unity of the country, the symbol of the nation; on the other side, it represents a partisan role, and those two are in conflict. In some other systems, such as parliamentary systems, you have a king or an elected president who represents a country when he travels and so forth, and then a prime minister; and that is not the case in the United States. The other thing is that the United States does not really have a professional bureaucracy of civil servants who are there permanently. In the United States, the president brings in his own new team. They have to have some experience in positions of power and so on, but you don't have a kind of permanent staff.

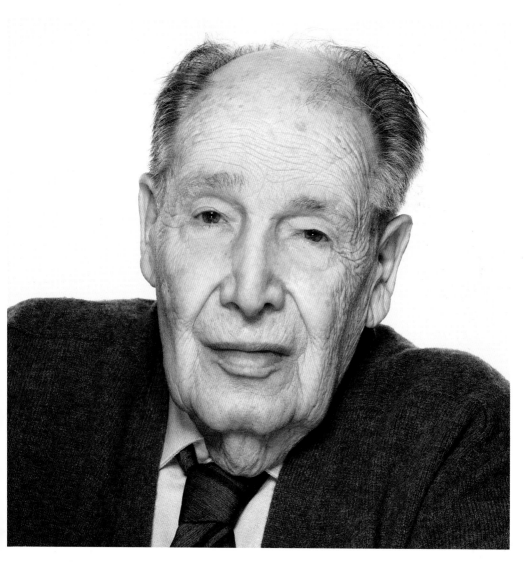

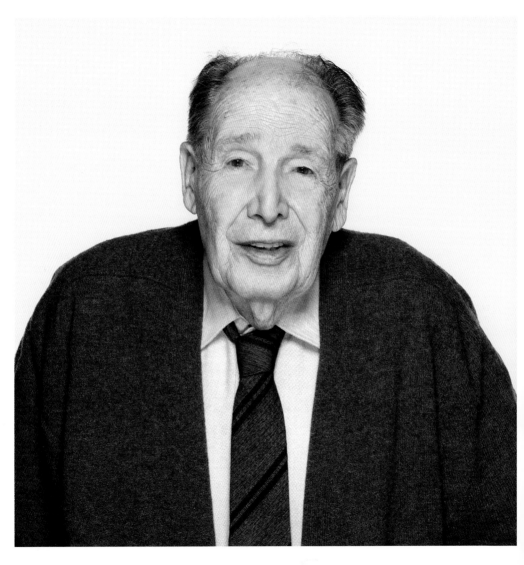

It has to be created or recruited for each new president. So the president does not have an easy job. But governing is not an easy job and governing a country of the size and the complexity and the power of the United States is even more difficult. One assumes that a president must have courage, honesty, loyalty, intelligence, and the capacity to move people within the political class, but also the citizens. So that's partly rhetoric, partly personality, partly ideas. Then there's the capacity for work and daily management, and the ability to face a crisis.

What is amazing in a sense is how many regimes— totalitarian and some non-totalitarian too—exceed the need of repression and violence to keep governing. To be in power is not that difficult, even without an organized structure, if you have the loyalty of the armed forces and the police. Some of the regimes that have crumbled, like the Fascists in Italy and Nazi Germany, crumbled because they were defeated in war, not because the people rebelled. In Germany and the Soviet Union, rebellion was not possible. In the Soviet Union, they themselves decided that it didn't make sense to keep that system going as it was and tried to reform it. It's only when they tried to improve or correct the problems in a system that they got more opposition and more discontent.

If you go into academia, do not be completely bound by the fads of the time, the dominant theories or the dominant methodologies. The fundamental thing for a student in any of the social sciences particularly, but in any field, is to be curious, to be passionate about getting to know more.

Be curious; be interested in the world. Your satisfaction is in what you know. Before you started reading something or writing or doing your research or doing some interviews or analyzing some survey data, you didn't know something, and at the end of the day, you got to know something you didn't know before and that other people didn't know before, that you can communicate to other people. The creation of knowledge is a great satisfaction.

I'm curious about life, period.

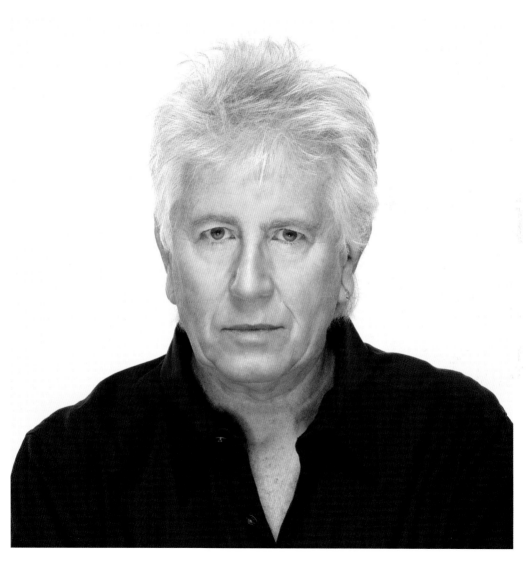

I went out with Joni one morning, we had breakfast and she bought this vase that she liked in an antique store, and she brought it home and I lit the fire and she put flowers in the vase. A totally, completely normal situation. But I felt like I needed to go to the piano and say something about this ordinary moment with me and Joni, and the result was "Our House." I felt "Our House" coming through me. Normally I feel my songs coming from my insides, from whatever it is in there, a combination of my heart and my brain. Normally I feel it coming from me, but in that particular instance of "Our House" I felt it coming through me, and it was a different feeling, very different.

My father was a very simple man; we were quite poor. He bought a camera from a friend of his at work and he would take me and my one sister to the zoo and take pictures of us, and I'd take a couple of pictures with his camera and then he'd set up a darkroom. We only had four rooms in the entire house and they were very small, so he would take my bedroom and he'd put my blanket from the bed up against the window to block the light out, and he put a black piece of paper into a colorless liquid and waited and waited and waited, and then this image floated into view. My life has never been the same since that moment. That was a magic trick that I couldn't believe. Where did this image come from? Did little pieces of it fall from the sky onto the picture? How did this happen? That magic moment has never left me, to this moment. When I saw a particular image, which was a photograph taken by Diane Arbus of a boy in Central Park with a hand grenade, it was the first photograph I ever was moved to buy. And the reason I bought it was that it was showing me something about myself and my fellow human beings that I was aware of but not deeply aware of, that there's an insanity that lives in all of us that can be triggered or can be not triggered. We all have the propensity for incredible violence and incredible love all at the same time. It's one of the human conditions that puzzles me greatly. So I've always wanted to see an image, want it enough to buy it, and then hang it in my house and look at it every time I walk down the hallway and have my kids look at it. Then I would change them to more ridiculous images and I would constantly revolve the images that I had, whether it be photographers, or Escher, or German Expressionist woodblocks, or anything that I thought would keep their mind moving. That's why I collect and that's why I show.

A photograph can be more than a record of that particular moment when it's all *right*. When the cameraman is looking through the viewfinder and it locks into place: the composition, the moment, the look in the eye. When the photographer feels that moment, like Cartier-Bresson said, "The decisive

moment," you take that shot. If you can take a still image that moves, meaning not physically moving as in a movie, but that you can look at that image and it will move your spirit, you can go, "Wow, I didn't realize that," or, "I'm learning more about myself," or, "I'm learning more about my fellow human beings," or, "I'm learning more about the rest of my world here," that still image has a tremendous power to move and that's what I'm interested in—finding images that make me look at it and go, wow, there's more there than meets the eye, I have to fall into this image and learn what it has to teach me.

I find it very difficult to collaborate with music. For instance, if I have a melody that I think is a particularly beautiful melody and I go to somebody and say, "Look, I've been struggling to put words to this and they're not coming, what do you see?"—and he starts to write a song about a pig in pink pajamas to my melody, I'm out of there. Maybe I shouldn't be so against it, but I just find it uncomfortable to be writing with another mind when my mind wants to go in a certain direction with my music and my lyrics. I find it difficult to collaborate. I have collaborated with other people. Crosby, of course, is my main collaborator, musically. I just recently wrote a song with Carole King because we saw each other at a concert and she said, "So, when are we going to write together?" and I said, "I'm not the guy." She said, "Oh, fine, I'll be at your house at one o'clock." I said, "What?" She said, "I'll be at your house at one o'clock and we'll write." I said, "Didn't I just get through telling you?" She said, "I don't care what you just said, I'm coming to your house at one o'clock. We can do this." And we ended up writing a pretty good song. So it was an interesting lesson for me. Maybe I need to be not quite so controlling with my music. Maybe I should open up my heart more and my brain more.

I have had numerous friends that have gone blank when it comes to writing. They have a writer's block or something. It's never happened to me, because what I've discovered in my life is that if ever I'm tired of using one muscle, I'll use another muscle. And what I mean by that is, if I don't feel inspired to take photographs, then I'll pick up a hammer and chisel and start banging away on a piece of marble, or I will do a linocut…there are a million things that I can do with my creative energy.

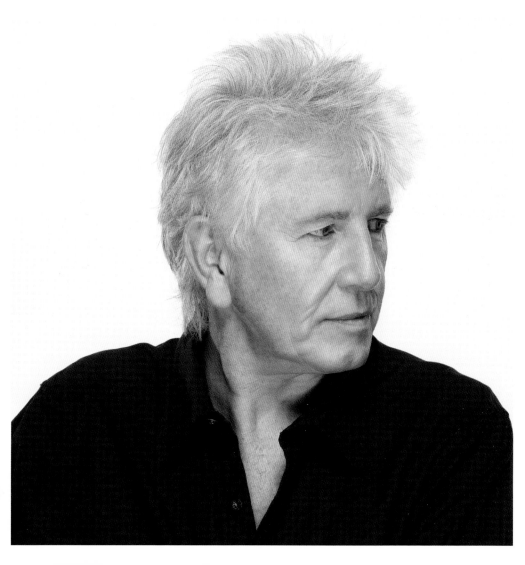

And if I ever feel that one particular part of my energy is not awake today, then I'll use another part of my energy, right? So then when I come back to writing songs, or I come back to photography, or I come back to sculpting, I'm fresh. It benefits me greatly because I don't wear out one particular muscle, and have the others atrophy. I want to keep all my muscles moving.

Judi Dench

I feel that I'm constantly learning, in every single thing I've ever done.

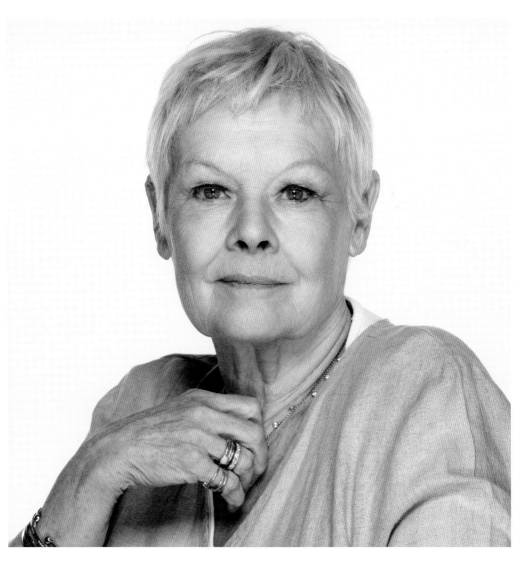

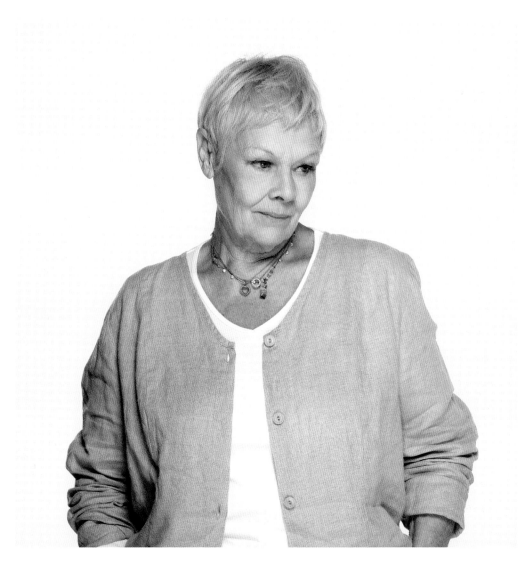

I've never, ever, in fifty-one years, done a play that has come easy to me. And I've fallen over in every play I've done except three in fifty-one years, too; in *A Little Night Music* I fell over three times. I can't keep upright.

Theater is a nightly job. You hope that it's going to get better. The wonderful thing about the theater is you get another turn. You think, well, that was a stuff-up; I'll do it better tomorrow, or the next day.

Discipline is what I have learned from acting. I don't have much quiet in me; that's why I'm a Quaker. I find that that gives me a kind of center that I need. Otherwise I would flip, here, there, and everywhere. So I kind of feel that that is my roots and without that I would be lost. It just gives me a still center. Sometimes it's not very still, but most of the time.

To learn the craft of acting, the one thing you must always do is just watch. Watch all the time, watch what other people do. When I was at the Vic I used to stand at the side of the stage and watch all the time. Not just your scenes, but all the scenes you're not in, because you always learn. And always, with a play, if you watch and you listen to the audience, you know what the pace of the next scene should be. It's an all-embracing thing.

If you're taken up too much with being famous and doing things like having to wear really expensive clothes and things, you don't get enough time to actually think about what you're doing. I have no time for fame with nothing behind it.

The theater community is the only thing I'm interested in, really. I've been asked so many times to do a one-woman show and I could not possibly do it. I know who I'm doing it for eventually, but I wouldn't know how to use the half beforehand. So much of it is your attitude toward the other actors: you're making something, you are all telling the story of an author, and that's why I love the community so much. You only rely on them, for everything. I learnt that very early on at the Old Vic in 1957; John Neville was playing Hamlet and running the company and I really learnt from him that every single member of the company is very important, and they all contribute. It isn't a question of just a few people in a company playing the large parts. It's absolutely everybody. I hope I've carried that out in fifty-one years.

I don't ever read scripts, not because I don't enjoy reading, but I like to push myself to the fear level of going to fall right off the cliff. On the first reading of *Antony and Cleopatra*, Tony Hopkins and I didn't quite know what happened at the end. It makes you so frightened. It's frightening having to act; and the more you do, the more frightened you get. But there is something about the fear that's absolutely wonderful. When I played Cleopatra, people used to look at me and say, "What are you going to do?" And I'd say, "Cleopatra." They used to look at me and say, "Really?" The fear of it was such a challenge. Perhaps that's what I need.

There's a huge difference between being in the dressing room and walking on to this: "Ladies and gentlemen, Billy Connolly." You go, "Whoop!" You become another guy. Something happens. Something between anger, coffee, and adrenaline. All of that combined—whoop—takes you up to this other place. And it's a joy and you forget the anxiety right away as soon as your feet are walking on. Whoop! Five minutes ago you wanted to run away.

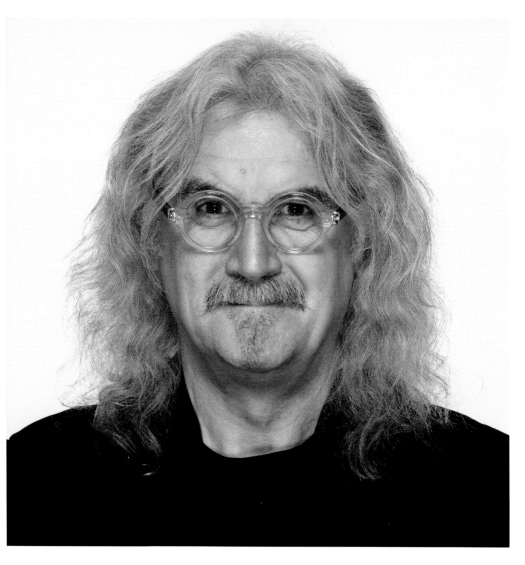

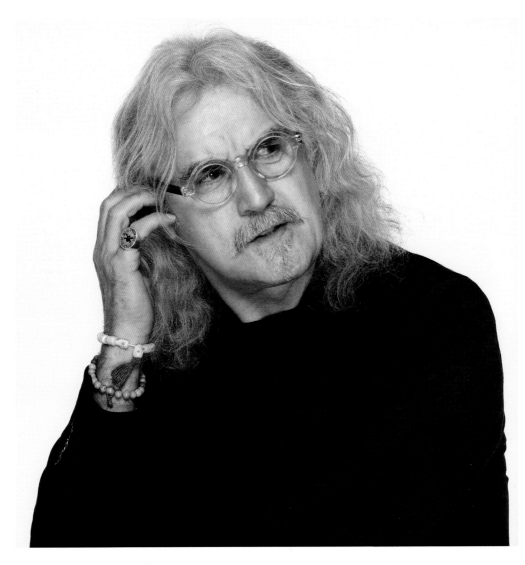

Stand-up comedy is not a choice you make; it chooses you. I always felt that it had chosen me. It was forced on me, like a vocational thing. I was doing it when I was a little boy at school. And when I was an apprentice welder, I was trying to be a funny apprentice welder. When I was in the army, I was trying to be a funny soldier. When I was a boy at school, about fourteen, there was a science teacher who was going around the class asking everybody what they wanted to be. All the guys wanted to be marine engineers. In Glasgow, you were born to be a marine engineer. Half of it, the idea was to get the hell out of Glasgow—get on a ship and go and see Hawaii and Africa and India. And he came to me and I said, "A comedian," and everybody exploded with laughter. I'll never forget it. The teacher said, "Well, Connolly, I saw you playing football at lunchtime. I think you've already achieved your ambition." And they all laughed again. It was supposed to be a put-down— although he was a very nice man—but I remember saying, "Yes!" I remember saying, "God, I've said it. I've actually said it!"

The fear of going onstage is very complex. It's not really a fear; it's a deep anxiety. Because of the nature of what I do, I have loads of stuff I can say. If I don't get a single idea, I'll be okay. There's things I can say and do. But if I don't get an idea, I'm unhappy. It hasn't been a good night for me if I haven't said something I've never said before— even just a sentence. Sometimes it comes in lumps twenty minutes long, which is like flying— it's an amazing thing. So if I don't get any of that, it's been a bad night. I often think, "Well, I don't know what it is. I'm just delighted it shows up on the same night as I do." And then, as I've got older, I've thought, "What if it doesn't show up?" It never occurred to me before that it might not show up. And it's a ludicrous idea because it's inside me. It's not as if it's something flying along that I have to catch every night. So I sometimes get deeply anxious that it won't show up.

Luc Montagnier

I was curious, at the age of fifteen, where I came from, where I was going. And I thought science could give the answer. Curiosity is really the main moving force in research. Once you answer one question, you have another one, and so on and so on, and you are obliged to continue all the time. Which is what I'm trying to do until I die. I hate the idea of retirement.

Research is hard work, but you need imagination, too. There are more things occurring than what we see before us. We don't know enough about nature, but we are starting to keep up with what we observe. Our lives are short compared to nature, so we have to learn from the people who come before us.

What is fun in research is to find something you're not expecting to find. That's always a good surprise and I was lucky to have several of those kinds of surprises in my research life. You have the mind of an explorer, actually. We explore miniature things, molecules, even atoms. It's very interesting and very moving.

Scientific knowledge is immense and one single brain cannot keep everything in its memory. So we have some technology and some other people have complementary technology that we use to assemble all the knowledge. But that doesn't mean you have to follow ideas of the others. You have to have a brain and try to be original.

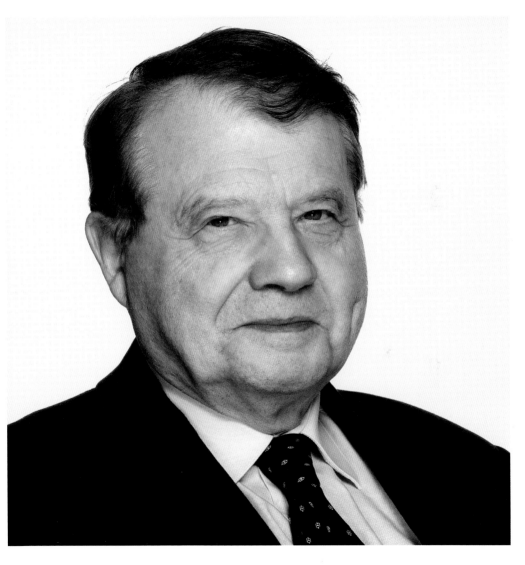

Acting has that little fatality in it that you might not pull it off. You could fail horribly here. And embracing that uncertainty is actually the creative process. That's what gives you the juice to go. And if it doesn't scare you, then don't do it. Even as you get older, that's still there.

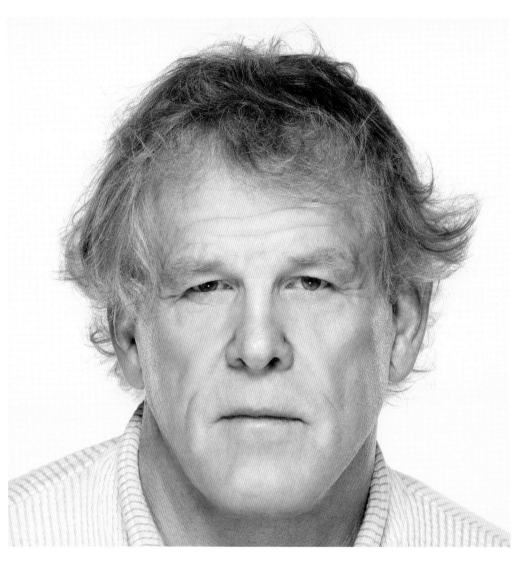

Acting, in an odd way, was an art form in which I could practice life without the consequences. I say that facetiously because the actor truly is his instrument and he's truly exploring different feelings, emotions, where they come from, how they come. It's just a continuing exploration as far as acting goes, because as you grow older your acting changes, you know, just your whole mental ideas and your feelings about things change.

There was an experiment done with mice and they were trying to find out how mice grew dendrites in the brain. They wanted to know what conditions caused the brain to really grow. So they took one mouse and they put him in a cage and they gave him everything he wanted: food, everything, he had everything. They put another mouse in a cage, he had everything, but he had to run a treadmill. And then the third mouse, they put him in a cage and twice a week they took him out and put him through a maze, but not a maze that was just going like this, it almost threatened his life. I mean, he had to go up a pole and he'd be twenty feet above a tub of water below, and, you know, enough to put a little edge to it…and they had MRI'd the brains of these mice, and afterwards they sliced up the brains to look at dendrite growth. Well, the mouse that had everything, he didn't grow a single dendrite, didn't grow at all. The mouse that had to run, he grew dendrites, but he didn't connect them. And the mouse that had to survive, he grew a lot of dendrites and connected them all.

Buzz Aldrin

Fear is a paralyzing emotion.

People who deal with dangerous situations, especially in combat, learn that they have to control that and concentrate on the better paths that can be selected. There are a lot of unknowns in combat, and so you have to be ready to anticipate. Space doesn't really have that many unknowns. You can make things worse by too rapid a response, so you have to have a basic understanding. That gives you a clarity and a simplicity and a sense of being on top of the situation, rather than waiting to see what's going to happen and how you're going to deal with it.

Great stories teach you something. That's one of the reasons I haven't slipped into some sort of retirement: I always feel like I'm learning something new.

There was a time in my life when I was doing Westerns, on the plains of Spain with the Italian companies. I could have stayed there and probably knocked out a dozen more of them. But there was a time when I said, "That's enough of that." As fun as they were to do and as much fun as it was working with Sergio Leone and Antonio Delli Colli and all these wonderful talents, it was time to move on. I suppose I would feel that way about any story that I read. If I read a story that doesn't have anything that I can see that's fresh in it, at least for me, then I move away from it.

Václav Havel

Creation and destruction are two sides of the same coin. The whole of being is a conflict between creation and destruction, between life and death, and between being born and dying in the broadest sense of the word. The devastation of the landscape arouses existential angst within me because I perceive it as devastation of the human soul. My way of overcoming that angst has been to formulate my impressions, feelings, and ideas in literary works.

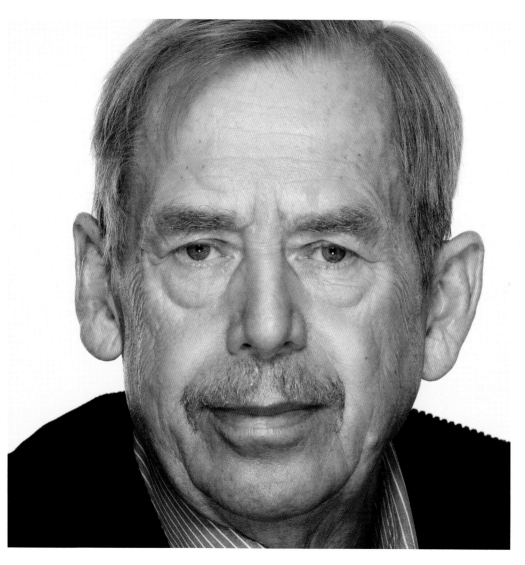

Frank Gehry

A new idea is obsolete in seconds, right? I just said it and now it's obsolete.

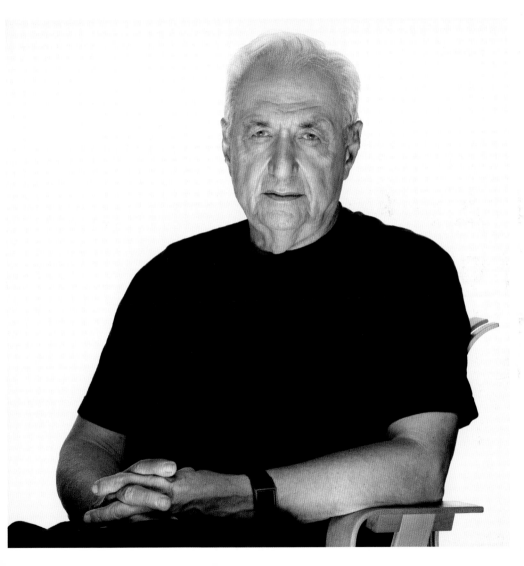

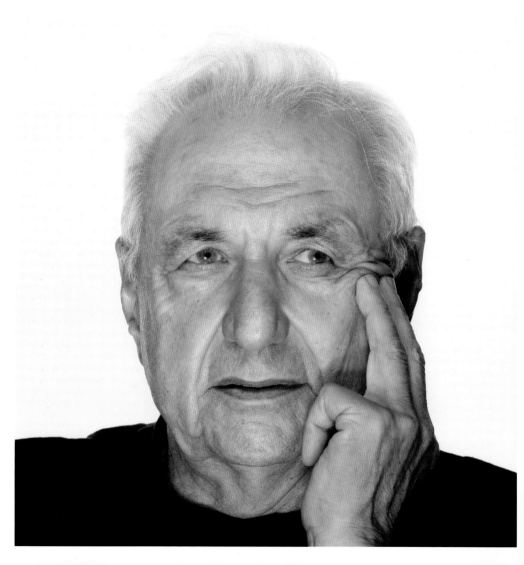

If you go into a gray concrete box with one little window, it's claustrophobic, it's cold. If you put a skylight in it and you make the window bigger and put a tree outside and put wood on the floor, it gets better. And it can get better and better until it becomes a humanistic space to which our bodies respond, our emotions respond.

"Fresh" is a kind of ephemeral quest. Intuitively, when I see something I've done before, I go away from it and I work with no preconceptions. It's like the pussycat with a ball of twine: the thing falls, you look, you're an opportunist, you take that idea and you go on to the next step and it's one intuitive step after another. It's being willing to accept the accident and move with it, and then build on it, and then take it to the next step and see what happens and go with it and to trust that. I've always done that and it always somehow works.

I don't think we should deny tradition. It's obvious that you have to learn from tradition. Almost everything you do has been done before in some form or another. We were asked to do the master plan for Harvard's expansion, and Larry Summers asked me, "If my faculty, my board, and a lot of people say that the business school is their favorite building on campus, why wouldn't I build everything in the future like that?" And that's difficult because I like that building too, and I like the architect—he's a good friend. The answer I had for him was: when you do that you're telling your kids and future generations that you didn't have a response to the time and place you live in, so you decided to use a model from the past. You didn't have an idea as to how to present the place in today's terms. What you're saying to future students is: go backwards to go forwards.

In the Renaissance, the distinction between art and architecture didn't come up. People moved effortlessly between the disciplines. They could even compose music and write sonnets and sing. For me, there's a moment of truth in deciding on form, space, color, composition. No matter that I put toilets in the building, no matter that I put electrical in, no matter that I have to keep the rain out—all of those functional issues. I still have to, at the moment of truth, make a decision very similar to what the painter does when he or she faces the canvas for the first brush stroke. Our culture today wants to separate art and architecture and call them different things. And that's fine. I call myself an architect just to preclude that discussion.

As soon as you tried to define beauty you'd be thwarted by finding something that one would think is ugly presented in a beautiful way and you'd be puzzled by it. You know you've got it when you've got it. You go out and you see the sunset, that's beauty, you see the hills, that's beauty, the trees are beauty, a beautiful woman, whatever, a beautiful painting. But it's these unexpected things that come about, like walking through an industrial district and seeing the profile of industrial buildings against the sky. Industrial buildings taken individually are horrible, but all of a sudden it's a beautiful scene to behold. Beauty is very elusive and difficult. And you probably should never try to define it.

Richard Rogers

Cities are the most complex and socially critical form of organization that mankind has created. Look at Athens around the time when the Parthenon was built. This was the city which was the catalyst for an amazing period in history, when civilization really took a leap forward. Whether in science or the arts, immensely wise decisions were made by the government and people of Athens which—in a sense—we're still building on today. One might say that although we build the cities, it is the cities that shape us.

Architects take their commissions from their clients. You get a brief—whether it's for a single house or the major redevelopment of a large city —and you analyze it. It may take some time before something starts to click, and you need to work very closely with your clients to move forward. The worst scenario—in my view—is being given a blank piece of paper and being asked to come up with a response. I enjoy the constraints that clients bring to the debate; I enjoy challenging the client, and responding to the client's own challenges.

The team I work with today at my practice, Rogers Stirk Harbour + Partners, has developed a "language" of architecture based on a number of key drivers including "transparency," "lightness," "flexibility," "movement," "sense of place," "environmentally responsible," "democracy," "process of construction," and so on. We celebrate these drivers in our architecture; for example, we celebrate the process of construction by making it highly visible, or we celebrate movement by putting the lifts and stairs on the outside of our buildings. My team communicates using this vocabulary. And, as language is about giving order to the way we communicate as human beings, architecture is about giving order to space. It's about the play of light and shadow on mass. I am fascinated by playing—aesthetically—with all these elements.

Ultimately, architecture has to be responsible to society. I like cities because of that word with which they are inexorably linked, "citizenship." Architecture is about people, first and foremost. You get form for your architecture from the community that it serves—and not the other way round.

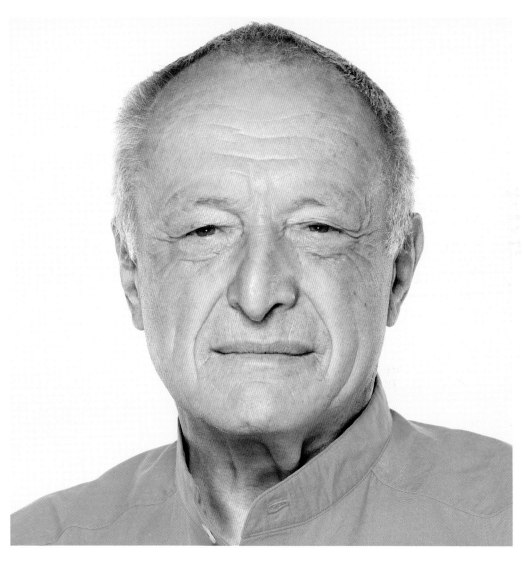

Once the whole design team is involved in discussion with the client, you get what I call the "ping-ponging" of ideas. That's what I really enjoy about the design process and that's what creates the ideas that eventually become buildings.

Vanessa Redgrave

Theater helps people keep sane.

I think it's very important to help theater happen, both theater for children and theater for young people. Participatory theater, not just theater to sit and watch but to make theater. I've done a lot of that kind of work, leaping on to a flatbed truck that I've managed to get hold of in the middle of a refugee camp with some other refugees and making some songs and some sketches up and something like that, or helping a three-day festival with brilliant artists coming from all over the world to join some of the musicians and directors and theater actors of Albanian Kosovo. That's the sort of thing an artist can do and that's what I do. Without getting more complicated as to the role of theater in society, those are things that an artist can do. Artists can do an awful lot.

Harald zur Hausen

The scientific community is very important. First of all, you need to get your results confirmed by other groups in order to achieve acceptance. Secondly, of course, many stimulating things come out of discussions with other scientists and scientific groups. The discussion of ideas brings up new approaches to experimentation. I regard it as one of the most important things, to be open to the scientific community and not to hide your own data. The openness in science should not disappear and we should do everything to preserve it. You have to be open to new ideas and for new ways to approach problems. Collaborations are very important. In science, it's usually much more effective to work in a team.

Inspiration, as far as science is concerned, is slightly different from the inspiration of writers and musicians and so forth. It's the sudden feeling that a certain direction might be better than another one for a while, and subsequently it's more a matter of hard work to prove your point. And it's exciting when you eventually discover something that turns out to be important. But if I look back at my own career, inspiration was less a sudden "Eureka!" experience than careful work along the way to prove your point. I've worked now for thirty-seven years on papilloma viruses and human cancer and it was really laborious. I've had a few "Eurekas!", but I was really working out a carefully outlined plan.

It's quite important to be aware of serendipity. You find something on your way which may not lead you directly to the initial aim but which turns out to be quite important and which, in some instances, turns out to be of some importance.

Jacques Pépin

Whether you are a photographer or surgeon or someone who works with his hands, a cabinet-maker and all that, you have to know your trade inside and out, and control it.

To be a good chef, you have to be a good technician first. It does take time, and it's a very thorough and very disciplined part of the learning process to be a good technician. If you happen to have talent, however, then the technique allows the talent to show, it takes it somewhere. If you are not a good technician, even if you are talented you cannot show it off, because you don't have the knowledge in your fingers to do it. I've painted for forty years, I've had exhibits of my paintings—but I have never spent hours and hours on the technique, so I have no control over it. Sometimes I feel it comes out fairly good, sometimes I make a mess—but I don't know what I'm doing. You can stay five years in a studio and learn how to mix yellow and blue to make green, and what you do with your thumb or with a spatula and all that, and the law of perspective, and you come out and you do one painting after another. Does that make you an artist? Not really; you are a good technician. But if you happen to have talent and the knowledge of the trade in your hand, then you can take it somewhere. Often, you reject all of the technique. Like in painting, you paint and you reject everything. But the fact of rejecting implies that you have acquired technique: otherwise there is nothing to reject.

Rosamunde Pilcher

If I really wanted to write something very quickly and earn a bit of money, like a short story, I could very often just actually squeeze it out of my brain, and it worked. I was very good at short stories, which is quite a difficult craft. I have a complete instinct for doing short stories, which was very lucky. I became very practiced at them. I could write a short story out of anything. I don't remember ever having been troubled by a blank mind. There were times when maybe I was having a baby or something, and I'd have ten days in hospital and that was very good creative time because nobody bothered you and you could start all sorts of threads of stories. They were just stored away in your subconscious and came out again. I always had quite a lot of stories just hanging around the back of my mind waiting to be written down.

Say a man and a woman are together, quarrelling, or falling in love, but they're together and they may be out on a walk, talking things over on a cliff. I think an awful lot of writers would just do dialogue, basically, because that's what the scene is about. To me, it is terribly important, if I'm reading a book, to know, okay, they're on the cliff. What sort of a day is it? Is there a wind? Which way is the wind coming? Are the seagulls making a din or have they all flown inland? Is it high tide? Is it low tide? What time of the year is it? Are the spring flowers out on the cliffs, or has the bracken turned brown because it's autumn? Is the wind cold? Is the wind warm? Is there anyone else on the cliff? It's only by doing that, that I can really move into the physical contact between the two characters. I have to know, I have to smell everything before I can project the couple into the scene.

Ravi Shankar

Music transcends all barriers.

Jane Goodall

People have different ideas as to why we are these unique animals. The human animal is different. The chimp brain and the human brain are almost the same, but the chimp is smaller, and what makes us uniquely human, what has led to the explosion of the intellect, is the fact that at some point in our evolutionary history we developed a sophisticated spoken language that enabled us to teach about things that weren't present, to think back to the past and share memories, to plan for the distant future, and, perhaps most important of all, to have discussions so that you can bring in people from different areas and they can contribute their own unique wisdom and insights, and that can lead to all kinds of exciting ideas.

I never had fear of being alone. As a child, I dreamed of going to Africa, living there with the animals, and there wasn't a day that passed that I wasn't almost disbelieving that such an amazing thing had happened. And being out on my own in nature, with or without the chimpanzees, is just something I really crave for today and I loved it at the time.

For my scientific work, of course, it was desperately important to keep a very careful account of everything, which eventually led to track sheets and things like that, but I always kept a journal. I kept a journal as a child. And I think one's memory can play tricks on you, and if you write things down at the time, one, it's pretty wonderful to go back to who you were twenty years ago and read how you felt then but, two, you can go back and verify that your memory of today is actually what happened.

Our inspiration comes completely out of the problem at hand. It's amazing: every problem, every project, every situation has its own realities and automatically triggers a way to interpret them or to solve that problem.

M

Look where the problem is, and try to solve the problem. Sometimes the problem is at the end, sometimes the problem is at the beginning. In the case of the Heller dishes, the problem was at the end, because you eat and then it becomes a garbage plate. So you start by cleaning up the garbage plate. You collect everything, you stack them up, and you have a clean pile of dirty dishes. That is a solution. So we start from the bad aspect—the messiness of a plate at the end of a meal—and make it nice. It's like that on whatever project, basically.

L

You have to understand the problem.

M

It depends on if we're doing graphics or if we're doing a product. In graphics, simplicity and the cinematic aspect is important. All the elements are part of the vocabulary, or part of the bag of tools that we have to achieve certain inspiration with, whatever it is we are doing. And if it's a product, again there is an element of…

L

…the material way of doing it.

M

In relation to the body, to surprise. Neutrality and simplicity can be powerful tools for communication, because they're clean.

L

Because they work, most of the time.

M

There is no fragmentation. There is no interruption by other distracting elements, so the straighter it is, the better it is; the better it communicates, the better it gets to you.

L

But it works, also.

M

But it works. The problem, generally speaking, is people like to put many things into one bag and then the bag breaks down. The trick is to have the right size bag for the right size content.

M

We think about design twenty-four hours. I don't think of anything else. Everything goes through that. You need to have a passion. And everything becomes that life. Talking with your tools.

L

One of the things that we are really proud of is that our design is sort of timeless; it doesn't go out of fashion.

M

It's never in fashion.

L

But it survives. And you appreciate that, after so many years. That is really what gives satisfaction and makes us think that we might be on the right track. And we are looking with a, sort of, "What?" when we see the strange things they're trying to do today in architecture. Everybody has to be a Gehry.

M

Not everybody is that good. But that's okay. The greatest thing I've learned in my life is that there is room for everybody. That's the great thing about art, and design, and communication: there's really room for everybody. And everybody has his own audience, too, to a certain extent, so it's fine. It's definitely worth it to keep yourself as pure as you can, so that your voice comes out as crisp and clear as it can.

M

There are many interpretations of the notion of collaboration. My interpretation, or our interpretation, is that collaboration doesn't mean both of us holding the same pencil, fighting each other, this way, that way, this way. Collaboration is sharing a philosophical platform. We have something in common. And to have elective affinities. That makes us understand a problem and provide the proper diagnosis so that we can work together. Then, who's working on it is irrelevant to a certain extent, because we fuse. But at the same time, while we have fusion, we also have a diversity. Lella is much more practical than I am, so she can point out my weakness on that practical side. And I push in the other direction sometimes, so there is that continuous flow going from one side to the other.

L

Naturally, you have your own opinion. Your own opinions, many times, are very good. I balance the dreams of Massimo—always flying high—with what is reality. Sometimes I have to take him down a bit. The thing that was good for us is that we met when we were very young, and we've been together, and so we grow together in our interests, in what we like, and what we don't like, and what we discuss…judgment of design that we see, or architecture. We end up having the same interests. So the fact of growing together, through life, your intellectual capability is really what they call collaboration. The fact that you think the same way, or very close to the same way.

L

When we do a project, we work by subtraction. We come out, perhaps, with one or two ideas, and then start criticizing our ideas. But always giving a reason for the criticizing. Then we come to the heart of the problem and we feel that what we've answered filled the need.

M

Our process of working is really symbiotic in a sense. First we look for the semantic roots of whatever we do, and then we look for a consistency throughout, called a syntactical aspect.

L

Yes, exactly.

M

And then the pragmatic aspect—where she comes in—to see if everything works. Because if it doesn't work, if it's not understood, you might as well forget it. This is why design is different from art. Design has to be understood. It is a utilitarian profession.

Art is not utilitarian. That's why design is. We always function for a utilitarian purpose. It takes a tremendous amount of courage to do things that have no utilitarian destination, and have the same kind of intensity, intention. And that is fascinating. Somehow, sometimes, the two things could be related, design and art. But what is never going to change is that one is utilitarian and one is not.

Between the idea and the execution, the idea is first. This is the greatest thing about ideas: either they come right away, or forget it. It's terrific, that moment where you are interpreting the problem, whatever it is, and you come up with a solution. But, of course, it's your interpretation of a reality that counts; there's no reality, in a sense. It's your interpretation of the reality. Even objectivity, which has always been our research, is a very subjective interpretation. So we live with these nice contradictions within ourselves.

M

One day, when we have a lot of good designers, we will have good things, or at least we will have fewer bad things. There will always be bad things, and we need them, too, otherwise we will lose our critical mind. We need bad things to help us see how good things are. There will always be bad—don't be afraid of it. But we can certainly increase the number of good things by increasing the number of good designer.

L

Educated designers.

M

The same happens in medicine. It's just another profession. I always make the comparison with medicine because we are in the business of curing people.

L

Curing their problems.

M

And then making them feel better.

L

I would tell aspiring designers that the first things you have to know are the good things that happened before. They should just start looking at the actual panorama now. They should have a little history of design. Go back and see some good things that were done before.

M

Learn from the past if you want what matters in the present. Knowledge is really the most important thing. Without knowledge, there is nothing that can come out of any value. To the young people, we say, fill your brain with as much information as you possibly can. Look at everything, know everything, develop a critical mind. History, theory, and criticism are the three fundamental elements to grow in a professional life. History will provide you with the tool for understanding. Criticism will provide you with the ability of continuously mastering what you are doing. And theory will be the backbone of what you're doing, why you're doing it. You continuously play with these tools and you can do pretty good things.

Helmut Jahn

Simplicity is a sign of maturity. It takes time to get simpler.

Collaboration, teamwork, working together, not only in architecture, but in every discipline of life, are the foundations of actually being successful. The ideas might emerge from me, but how they are executed is ultimately the measure of success.

In the mid-1980s I started collaborating more with engineers, and then the architect started to think like the engineer, and the engineer started to make architectural judgments. I remember an engineer telling me, "Helmut, I don't think you can do that." I said, "What do you mean?" And she said, "It doesn't look good." Everybody had enough knowledge of the other one's field to keep everyone in tow, and that's where tremendous progress was made.

The basic thing about architecture is, obviously, an idea. The way we practice, and how I was educated, is: make a building as perfect as it can be. Very few people actually have the knowledge to judge architecture in the best way—they all judge it by the "wow factor." "Oh, have you ever seen this before?" It has always been very important to me, when I make even the first sketches, to think, "How does this get built? How can it get as perfect as possible, how will it perform over its lifespan, and how will it actually get better?" The good buildings actually get better. The Seagram Building in New York—still one of the best towers in New York—this building actually looks better now than in the sixties when it was built. And there are so many buildings we forget that might have been a splash when they were built. I still have a place in New York, and for Easter or Christmas the family goes to New York and we often go to the Four Seasons restaurant. It has a timeless quality, which is exactly what everybody looks for, and what so many people try to achieve in so many different ways.

There's a building in Guangzhou, China, that I did on the airplane flying back from the briefing. Right now we're doing a competition in China and I think we started with twenty-five schemes and yesterday I came down to four schemes, and then I brought it down to one. And everybody said, "But this is much simpler than all the other ones." I said, "Yeah, but simplicity is a sign of maturity. It takes time to get simpler."

We put much less emphasis on the aesthetic being the driving force in design and put a lot more emphasis on how buildings perform. In the long run, buildings have to be judged on how they perform. A lot of architects engage in just formal sculptures that can be realized with the help of technology. They don't actually do the profession

a long-term service; they don't actually drive our profession forward, in becoming more performance-oriented. You have to think of a building like a product, from which you expect performance. You expect performance from your phone, you expect performance from your computer, you expect performance from your car, your boat, and every tool you use. Your fountain pen: you always get mad if it doesn't work. A lot of buildings don't actually work. The idea that a building has to be as green as possible—which is a word I don't particularly like, because it lumps everything together in one big bag—I always think of it as hype. Architecture has had different phases: formal, brutalism, postmodernism, and now everything has to be green. But there *are* things everybody can do. You can put all the equipment in the building and take the sun and the wind and bring in the heat and collect the gray water and collect the rainwater and use it for irrigation. The most important thing, which hasn't been fully exploited, is that we use the renewable resources, of air, daylight, soil, and water. Those four elements are actually all free. Buildings can be designed to harvest those resources and use them in a way that can not only be more efficient, but they can also become more comfortable. Because it's nicer to be in a building that has more daylight, it's nicer to be in a building which has more fresh air. And it's nicer to have a building that doesn't have so much mechanical equipment. If I can use the soil or the water for the cooling or for heating, without big boilers, without huge cooling towers, I eliminate a lot of noise, I eliminate a lot of energy use. At the Deutsche Post building in Bonn, there's a roof garden on top of the building; there are no cooling towers because the water comes out from the Rhine, which is right next to it. Almost everywhere in the world you build, you can drill down in the ground and there's water, and that water is fifteen degrees, and it's cool in summer and it heats in winter. All you have to do is change the temperature a couple degrees. It's free energy.

I don't have to work any more. A lot of people don't *want* to work any more, because they don't like to work. I don't *have* to work, but I *like* to work, and only when you like to work can you actually do good things. Perfecting a design is a process which is only constrained by the limits of time: you have to go through the various phases, et cetera. That's why I always prefer jobs that go fast because otherwise you agonize too much. When you design a car you build thousands, hundreds of thousands, a million of them. Millions of products, computers, iPhones, whatever. But a building, you only do one. That's what makes it exciting. That's why I can't stop.

Mary Quant

Risk it,
go for it.

Life always gives you another chance, another go at it. It's very important to take enormous risks.

London, in the sixties, was this gray, drab place, this vacuum with nothing going on. There was nothing for the young; there was nothing happening. So it was really out of that vacuum that all this energy came together. There was the theater, the Royal Court, there were the painters, sculptors, artists, designers, food, clothes, everything came into it. It's very odd, but young people had to dress like old people. There was nothing for the young. It's extraordinary, in retrospect. There was nowhere for the young to eat. There were no films that had to do with their lives or theater that was provocative. And in every field this was it. Art didn't touch the reality of the way we wanted to live. Clothes simply weren't as available. They just weren't for young people at all. I think it was probably the only time in history where young people wanted to look middle-aged. That was the only thing available to them.

And to say they weren't sexy would be such an understatement! You couldn't live in them. You couldn't run after a bus, you couldn't dance, you couldn't move…let alone go to work and then go on to dance half the night. So that had to be done. What I was doing was designing clothes for people like myself. It was very, very straightforward. I was designing for me, being totally self-centered and selfish. Then, the artistic community clung together, we knew each other and met each other. Photography changed, film changed, everything changed. We egged each other on and clung together for more courage to push harder.

The more you do, the more you do, the more you do! You get into a rhythm where, first, so many ideas are needed and then so many ideas are coming to you that you can't bear to stop. And you really work and work and work, and you surround yourself with a team that will also go at a faster and faster pace and ideas just pour out.

One of the things I learnt was never to hoard ideas, because either they are not so relevant or they've gone stale. Whatever it is, pour them out.

Yoko Ono

I'm so open that sometimes it's dangerous! When an idea comes to me, I think, well, I have to dish this out. It's not coming so much from you but somehow up there, out in the air. And it's very important that you share your ideas. I think if I kept everything inside, I would be sick. Ew. Circulation's very important!

One of the reasons that art and music are so important is because we're free. We treasure freedom, and freedom of speech—which we don't always get—but we can communicate with people more easily. Politicians are always dealing with red tape.

Art was going in a rather strange direction. It became commodified art, selling for millions, et cetera. Now we are entering a beautiful age, where we can again become artists who are creating pure art. I just gave an award, the Courage Award for the Arts. Because I wanted to make sure that we cherish and express appreciation to artists who are just sticking to their ideas instead of thinking of making millions. It's very hard when the whole world is doing that "million, million" game, and there are artists who are just sticking to their ideas for forty, fifty years, and I think it's very important that there are people like that. Courage is not a word which is usually connected so much with art. So I wanted to give a Courage Award to an artist. Most people not only don't appreciate artists, but they make fun of us.

I'm very thankful for the hard times that I had. I can't say that I'm unique—everybody has hard times. But there are very few people who are really strongly hated by the whole world. And that was kind of like a blessing, because I had to find a way to cope with it. And while I was doing that, a lot of inspiration came to me.

I feel that when you start thinking together, it creates a kind of social climate. The more people focus on the same thing, the better. It makes it easier for things to happen. So community is very important. If the whole community starts to think about something together, it'll happen easier and quicker. New York is pretty good for that. People are very quick to understand things, and so a lot of people are thinking about imagining peace now. And anybody who's got the message, and who's imagining peace, they're collaborators. And there are thousands and thousands of people in the world who are now imagining peace. It's great.

Federico Mayor Zaragoza

For many centuries, we have been behaving in the framework of a culture of war. For over two thousand years we have said that if you wish for peace, prepare for war. We have been in a male society, therefore we immediately use our muscles instead of our capacities for thought. This was the very core of the proposals made by a very distinguished, very wise President of the United States, Franklin Roosevelt. At the end of the Second World War when the United Nations was founded, it began by saying, "We the peoples have resolved to save the succeeding generations from the discords of war." What does this mean? That we have decided now to build peace, not to prepare war. But, as often happens, because there is an immense machinery for war—an immense industry of weapons—here we are again; as happened with President Wilson in the year 1919, when we started again preparing for war. And we have war. When I was elected Director-General of UNESCO, I said, "Well now, what I must do is to put into practice the original mission of UNESCO that says that we must build the defenses of peace in the minds of men." And they said, "What is a very short expression of peace?" The answer: a culture of peace. We are living in a culture of war. Let us now have a culture of peace. Let us be prepared for a culture of peace. Instead of always thinking about how we can be stronger, let us now think about how we can be wiser. We will always have conflict. But we must prepare ourselves for dialogue, for understanding, for conciliation—instead of the imposition of violence.

The United States is an idea, basically.

I am a Liberal politician in the Continental sense of the word, and not the American sense. And one of the basic premises of the kind of Liberalism I believe in is a belief in the fundamental goodness of man. We share this with the Socialists, the difference being that the Socialists have an optimistic view of the government and Liberals have a pessimistic view of the government. This is also what separates us from the American liberals like Teddy Kennedy. The premise that man is fundamentally good is also the idea on which the United States is based. The United States is an idea, basically. And that idea is that if you let people go their own way, if you give people freedom, everything will come out for the best. Perhaps I should have known better, and perhaps the United States should have been more cynical, but the recent financial crisis shows that this particular idea has its limits. I should have known that all along and we all should have known it all along. It was fairly revealing when the former Chairman of the Fed said that he had thought that bankers should have been able to look after their shareholders better than they did—which is sort of a veiled way of saying that bankers overstepped the mark. That capitalism always searches for the borders and oversteps if left alone. The basic lesson

is that self-regulation is a beautiful thing, but often it has to be "filled in," if you like, with regulation.

I do not belong to the school of thought that says capitalism is down and out. That is ridiculous. If you think of the way prices are formed, they're either formed by bureaucrats or they're formed on the markets. And I don't think anybody wants to return to a system where bureaucrats determine prices. So we have to find a solution within the markets. And that means that we have nothing better than some form of capitalism; but that should, in some cases, be better regulated. The housing market is not the only market and banks are not the only participants in economic life, but in the case of the recent crisis, the banks should have been regulated better and should have regulated themselves better.

I don't think it would be wise to try and define the concept of wisdom. One has to deal with many different situations and many different people, and what is wise for one may not be wise for another. In particular, one should be cognizant of the fact that some people believe in a God and others don't. I am an agnostic, that is to say I do not know whether there is a God. I have no knowledge of that. But certainly I do not believe in a God that interferes with human life, as many people do. So there's a great difference between believers and non-believers. And what is wisdom for a believer may not be wisdom for a non-believer. There are also many different cultures. And what is wisdom for an Indian or a Chinese person may not be wisdom in my case. And, conversely, my idea of freedom may not sit well with an Indian or a Chinese. So one should be careful not to be categorical in an area where there many different views, visions, and ideals.

I grew up steeped in classical literature. And the Greek philosophers, of course, discussed at length the concept of wisdom. And what somebody like Aristotle came up with is that we should try and avoid extremes. The expression was: "Nothing too much." The best thing is not to search for the best nor for the worst, but the middle. And while that appears to be very useful advice, to my mind it leads to a somewhat anemic world. If we are all happy with the middle—if we avoid both extremes—that may make for a safe society, but also a boring society. By and large, we should try and be ambitious and try to get the best out of ourselves. Because if you do that you can achieve a state of being which must be related to something like wisdom.

Robert Redford

Independence allows you to remain true to yourself as an artist. Whatever your spiritual impulses are as an artist—who you are—it's easier to maintain that with independence. Once you start thinking about financial security, you're beginning to run the risk of eroding your true self as an artist. Once you start thinking about money, once you start thinking about security, I'm not sure you're going to be able to take the risks you need to take. You want to stay clear of that; let that part, hopefully, take care of itself.

I just can't stop working. Nothing excites me more than being inspired by a new creative idea. It's all part of being an artist. I get excited about ideas, and then I get excited about wanting to execute them, put it into action. I can't seem to control that, and that keeps me going. I don't spend a lot of time looking back, either. I do take into consideration failures and why they occurred, or painful moments; I don't believe in ignoring that stuff. But I also don't like spending a lot of time on successes of the past. I just don't. So I'm pretty much always looking forward: what's next, what new thing can I do?

Biographies

Chinua Achebe
16 November 1930
Ogidi, Gongola
Nigeria

Educated at the University of Ibadan, Chinua Achebe began his career with the Nigerian Broadcasting Corporation in 1954. In 1958 he published his first novel, *Things Fall Apart,* which was subsequently translated into over forty languages with sales in excess of eight million copies. With his focus on the clash between traditional culture and Western values, Achebe has become a major voice for African literature. He has written novels, poetry, short stories, children's books, and essay collections. Achebe was awarded the Commonwealth Poetry Prize in 1972 and the Man Booker International Prize for Fiction in 2007.

Richard Adams
9 May 1920
Newbury, Berkshire
England

Richard Adams was educated at the University of Oxford, where his studies were interrupted by six years' service in World War Two. He graduated in 1948 and joined the civil service. Adams's first book, *Watership Down,* was rejected by numerous publishers, but went on to win both the Carnegie Medal and the *Guardian* Children's Fiction Prize in 1972, and to date has sold more than fifty million copies worldwide. He became a full-time writer in 1974 and is a fellow of the Royal Society of Literature and the Royal Society of Arts.

Buzz Aldrin
20 January 1930
Montclair, New Jersey
USA

Buzz Aldrin graduated from West
Point Military Academy and
served in Korea and Germany as
a jet fighter pilot. He received his
doctorate in astronautics from
the Massachusetts Institute of
Technology, and was chosen by
NASA to join the astronaut corps
in 1963. Buzz and Neil Armstrong
became the first two men to set
foot on the moon on 20 July
1969 during the Apollo 11
mission. Upon his return, Aldrin
received many awards from
countries worldwide, including
the US Presidential Medal of
Freedom. He is the author of
seven books, with the latest
published in 2009 He travels and
lectures throughout the world
(with his wife of twenty years, Lois
Driggs Aldrin, a Stanford alumna)
sharing his latest ideas for
exploring the universe.

David Amram
17 November 1930
Philadelphia, Pennsylvania
USA

David Amram, a virtuoso musician
on piano, French horn, and flute,
as well as a variety of folk
instruments, studied at the
Oberlin Conservatory of Music
and George Washington
University, performed with the
National Symphony whilst still
a student, and was the first
composer-in-residence with the
New York Philharmonic in
1966–1967. He has composed
more than one hundred works,
including two operas and the
scores for many films—*The
Manchurian Candidate* and *Pull
My Daisy,* a collaboration with
Jack Kerouac—among them. He
continues to perform as a guest
conductor for orchestras around
the world, and tours regularly with
his own quartet.

Alan Arkin
26 March 1934
New York, New York
USA

Alan Arkin formed the folk group
The Tarriers after dropping out
of college, and co-wrote "The
Banana Boat Song," which would
later become a hit for Harry
Belafonte. His screen debut came
in 1957, followed by roles on and
off Broadway, and he won a
Tony Award in 1963 for *Enter
Laughing*. Arkin's role in *The
Russians Are Coming* earned him
the first of three Academy Award
nominations. In 2006 Arkin won
an Academy Award for his role
in the film *Little Miss Sunshine.*
He has written numerous songs,
as well as science fiction and
children's books.

Burt Bacharach
12 May 1928
Kansas City, Missouri
USA

Burt Bacharach studied music at McGill University, the Mannes School of Music, and the Music Academy of the West. He spent two years in the army playing piano before teaming up with lyricist Hal David in 1957. The pair wrote twenty-two Top 40 hits for Dionne Warwick, including "Do You Know the Way to San Jose?", as well as songs for many other performers. Bacharach's fifty-year run on the charts includes seventy Top 40 hits in the USA, fifty-two Top 40 hits in the UK, over five hundred compositions, three Academy Awards (two for "Raindrops Keep Falling on My Head" and one for "Arthur's Theme"), and six Grammy Awards.

Frederik Bolkestein
4 April 1933
Amsterdam, North Holland
The Netherlands

Frederik Bolkestein received his Bachelor of Science from the London School of Economics in 1963, and his Master of Laws degree from Leiden University in 1965. Bolkestein worked for Royal Dutch Shell for fifteen years before entering Dutch politics. He served as the European Commissioner for the internal market, taxation, and the customs union from 1999 to 2004, where he spearheaded what is now known as the "Bolkestein Directive," aimed at creating a single market for service in the European Union.

Dave Brubeck
6 December 1920
Concord, California
USA

Dave Brubeck studied music at the University of the Pacific. He graduated in 1942 before serving in the US Army. After World War Two he continued his studies at Mills College under Darius Milhaud, who encouraged him to play jazz. In 1951, he formed the Dave Brubeck Quartet and released albums such as *Jazz Goes to College*. Brubeck's music is notable for unusual time signatures and his 1959 album *Time Out* included "Take Five" set in 5/4 time, which has become a jazz standard. He received a Grammy Lifetime Achievement Award in 1996.

Dick Bruna
23 August 1927
Utrecht
The Netherlands

Dick Bruna, who has written and illustrated over one hundred children's books, began his career as a graphic artist, and in 1955 wrote *Nijntje* (*Miffy*, in English) which has been translated into forty languages and made into a television series. Sales from his books exceed eighty million copies worldwide, and he regularly makes his illustrations available in support of UNICEF and other humanitarian organizations. Bruna was knighted in 1993 by Queen Beatrix and made a Companion of the Order of Oranje-Nassau.

Chuck Close
5 July 1940
Monroe, Washington
USA

Chuck Close studied art at the University of Washington and Yale University before winning a Fulbright scholarship to Vienna. His first solo exhibition in 1970 demonstrated his photorealism technique of breaking photographs into a grid and enlarging the contents of each square by hand, an approach for which he was to become well-known through his massive-scale portraits. In 1988, Close suffered a spinal blood clot that left him partially paralyzed and wheelchair-bound, but he continued to paint with a brush strapped onto his fingers. In 1998, New York's Museum of Modern Art mounted a major exhibition of his work.

Billy Connolly
24 November 1942
Glasgow
Scotland

Billy Connolly left school at the age of fifteen to become a shipyard welder before forming a folk-pop duo called The Humblebums, who recorded three albums. His first solo album, *Billy Connolly Live!*, released in 1972, featured Connolly as a singer-songwriter and musician but it wasn't until he appeared on BBC's *Parkinson* in 1975 that he became a household name as a comedian. In 2003, he was awarded a CBE (Commander of the British Empire) and a BAFTA Lifetime Achievement Award.

Bryce Courtenay
14 August 1933
Johannesburg, Gauteng
South Africa

A naturalized Australian, Bryce Courtenay's early years, before boarding school, were spent in a village in the Lebombo Mountains of South Africa. He later won a British university scholarship but was banned from returning to South Africa as a result of "politically unacceptable activity." Courtenay emigrated to Australia in the late 1950s and worked in advertising before taking up writing at the age of fifty-five. His first book, *The Power of One,* became an enduring bestseller. He has subsequently written over twenty books and remains one of Australia's most successful authors.

Judi Dench
9 December 1934
York, North Yorkshire
England

Considered one of the greatest actors of post-war Britain, Judi Dench trained at the Central School of Speech and Drama. In 1958, she made her Broadway debut in *Twelfth Night* and three years later she helped form the Royal Shakespeare Company. She broke into film in 1964, winning a BAFTA four years later for the TV series *Talking to a Stranger.* Her many awards include six Laurence Olivier Awards, a Tony, two Golden Globes, an Academy Award, and nine BAFTA awards. In 1988, she was awarded a DBE (Dame Commander of the British Empire) and, in 2005, a CHDBE (Companion of Honour).

Clint Eastwood
31 May 1930
San Francisco, California
USA

Clint Eastwood first found fame in 1959 in the television series *Rawhide.* He gained international stardom as a hired gun in the "spaghetti" Western *A Fistful of Dollars* (1964) and its sequels *For a Few Dollars More* and *The Good, the Bad and the Ugly.* Eastwood also starred in non-Westerns, such as 1971's *Dirty Harry*; a year that also saw his directorial debut with the thriller *Play Misty for Me.* He has continued to direct, and star in, a variety of movies, winning five Academy Awards as well as the Irving G. Thalberg Award for lifetime achievement in film production. In 2007, Eastwood was awarded the National Order of the Legion of Honour (France).

Frank Gehry
28 February 1929
Toronto, Ontario
Canada

Frank Gehry moved to Los Angeles in 1947 with his family, later studying architecture at the University of Southern California and city planning at the Harvard Graduate School of Design. His name soon became synonymous with sculptural buildings often clad in chain link or other inexpensive materials. Powered by a belief in architecture as an art form, Gehry's buildings include the ING Office Building or "Dancing House" in Prague (1996), the Guggenheim Museum in Bilbao (1997), the Walt Disney Concert Hall in Los Angeles (2003), and his own home in Santa Monica. In 1989, Gehry won the Pritzker Prize and in 2003 was awarded the Companion of the Order of Canada.

Jane Goodall
3 April 1934
London
England

Regarded as one of the world's authorities on chimpanzees, and the only human ever accepted into chimpanzee society, Jane Goodall began work as a secretary and film production assistant before traveling to Kenya, where she met anthropologist Louis Leakey, who helped her establish the Gombe Reserve project to study chimpanzees in the wild. She pioneered the study of chimpanzee behavior and society in the wild, observing that chimpanzees are omnivorous, make tools and weapons, and have a primitive "language" system. A renowned conservationist, Goodall has published numerous articles and books, and in 2003 was awarded a DBE (Dame Commander of the British Empire).

Nadine Gordimer
20 November 1923
Springs, Gauteng
South Africa

Nadine Gordimer published her first short story at the age of fifteen and went on to complete fourteen novels, nineteen short-story collections, several works of non-fiction, and a number of television scripts based on her works. Her writings center on the effects of apartheid, of which she was a passionate opponent, and have been translated into forty languages even though many of them were banned in South Africa. In 1974, Gordimer won the Booker Prize for Fiction for *The Conservationist*. She was awarded the Nobel Prize for Literature in 1991, and in 2007 became a Knight of the National Order of the Legion of Honour (France).

Harald zur Hausen
11 March 1936
Gelsenkirchen, North Rhine-Westphalia
Germany

Harald zur Hausen received his
Doctor of Medicine degree in
1960 from the University of
Düsseldorf. In 1965, he moved to
Philadelphia, where he contributed
to the discovery that a cancer
virus can transform healthy cells
into cancer cells. In 1983, zur
Hausen further developed this
finding when he identified two
versions of human papillomavirus
DNA as being the cause of about
seventy percent of human
cervical cancer cases. This
finding led to the creation of a
vaccine for HPV in 2006.
Zur Hausen shared the 2008
Nobel Prize in Physiology or
Medicine with Luc Montagnier
and Françoise Barré-Sinoussi.

Václav Havel
5 October 1936
Prague
Czech Republic

Because he was born into a
bourgeois family, Václav Havel
was barred from post-secondary
education in Communist
Czechoslovakia. He worked in
theater and became a playwright,
satirizing his country's totalitarian
regime, which led to numerous
imprisonments. In 1989, he
became a leader of Civic Forum, a
coalition struggling for democratic
reform, and when the Communist
regime capitulated, Havel became
the first non-Communist president
since 1948. The Federation
dissolved in 1992 and he was
elected first President of the new
Czech Republic, serving from
1993–2003. In 2003, Havel was
awarded the Gandhi Peace Prize.

Helmut Jahn
4 January 1940
Allersberg, Bavaria
Germany

Helmut Jahn studied architecture
in Munich before emigrating to the
US and furthering his studies at
the Illinois Institute of Technology
in Chicago. In 1967, he joined
C.F. Murphy Associates, which
was renamed Murphy/Jahn in
1981. Some of Jahn's most
recognized designs include the
State of Illinois Center in Chicago,
the Sony Center in Berlin, and the
HALO Headquarters in Niles,
Illinois. In 2002, he received the
Institute Honor Award of the
American Institute of Architects
for the Sony Center.

Kris Kristofferson
22 June 1936
Brownsville, Texas
USA

Kris Kristofferson won a Rhodes scholarship to the University of Oxford, and then served in the US Army as a helicopter pilot, eventually resigning to take up country music in Nashville. His compositions have been performed by over four hundred and fifty artists and he has recorded twenty-four albums. In 1971, he won a Grammy for "Help Me Make It Through the Night." He has also had a long screen career, with over one hundred film and television appearances including *A Star is Born* (1976), which earned him a Golden Globe for Best Actor. He was inducted into the Country Music Hall of Fame in 2004.

Juan José Linz
24 December 1926
Bonn, North Rhine-Westphalia
Germany

Juan José Linz was raised in Spain and gained degrees in economics, political science, and law at the University of Madrid. His studies on democracy and dictatorships, and their effects on a society, have made Linz a leader in the school of sociology. His seminal work, *Totalitarian and Authoritarian Regimes*, was published in 2000. Linz is presently Sterling Professor Emeritus of Political and Social Science at Yale University. He is also an honorary member of the Scientific Council at the Juan March Institute.

Jimmy Little
1937
Cummeragunga, New South Wales
Australia

After leaving school at the age of fifteen, Australian aboriginal Jimmy Little drew on his family background in music to launch his career. He made his radio debut as a teenager and toured with the Grand Ole Opry out of Nashville, Tennessee, in 1957. His first Australian hit came in 1959 with "Danny Boy," followed by many others including "Royal Telephone" in 1963. Along with a successful music career, Little has appeared in film and on television as well as teaching and mentoring Aboriginal people, a role which has earned him the moniker "Father of Reconciliation." He was awarded the Order of Australia in 2004.

Esther Mahlangu
11 November 1935
Middleburg, Mpumalanga
South Africa

In the tradition of the Ndebele, Esther Mahlangu was taught how to paint by her grandmother and mother at the age of ten, but her artistic flair emerged when, at puberty, she was taught the traditional craft of beadwork. As a teenager, Mahlangu became an expert in executing the traditional Ndebele art of wall painting and she was the first person to transfer the mural art form to canvas. Her work has been exhibited around the world, and in 1991 she became the first woman invited to paint a BMW car in the Art Car Collection, joining a group of artists that include David Hockney and Andy Warhol. She was also commissioned to paint the tail of a British Airways plane.

Kurt Masur
18 July 1927
Brieg, Silesia
Poland
(formerly in Germany)

Conductor Kurt Masur studied piano and cello in Breslau, and then moved to the Leipzig Conservatory to study piano, conducting, and composition. Masur has directed orchestras around the world, notably the New York Philharmonic, the Orchestre National de France, the Leipzig Gewandhaus Orchestra, the London Philharmonic and the Israel Philharmonic. He has made more than one hundred recordings and received numerous honors including the Cross with Star of the Order of Merits (Germany, 1995), the Gold Medal of Honor for Music (National Arts Club, USA, 1996), Commander of the National Order of the Legion of Honour (France, 1997), and the Commander Cross of Merit (Poland,1999).

Luc Montagnier
18 August 1932
Chabris, Centre
France

In 2008, Montagnier shared the 2008 Nobel Prize in Physiology or Medicine with Harald zur Hausen and Françoise Barré-Sinoussi for his discovery of HIV. After graduating from the University of Poitiers with a degree in natural sciences, he went on to gain his doctorate at the Sorbonne in 1960. From 1972, Montagnier directed the viral oncology unit at the Institut Pasteur in Paris, where he and his team isolated the human immunodeficiency virus, which was later identified as the cause of AIDS. Montagnier is co-founder of the World Foundation for AIDS Research and Prevention.

Jeanne Moreau
23 January 1928
Paris, Île-de-France
France

Jeanne Moreau trained at the Conservatoire in Paris. At the age of nineteen, she made her theatrical debut at the Avignon Festival. By the late 1950s, Moreau had transitioned into film and was directed by some of the period's best-known avant-garde directors. Her biggest success came under Francois Truffaut's direction in the film *Jules et Jim* in 1962. In 1988, the American Academy of Motion Pictures presented a life tribute to Moreau. In her career she has also worked behind the scenes as a writer, producer, and director.

Graham Nash
2 February 1942
Blackpool, Lancashire
England

Musician and photographer Graham Nash co-founded The Hollies in 1961, one of the UK's most successful groups whose hits included "On a Carousel." In 1968, he moved to the USA and formed Crosby, Stills & Nash, whose first release was the hit "Marrakesh Express," written by Nash. In 1969, they performed at Woodstock, the same year their first album won a Grammy Award. In 1990, he co-founded Nash Editions, a digital printmaking company, which was recognized in 2005 by the Smithsonian Institution for its role in the invention of digital fine art printing.

Nick Nolte
8 February 1941
Omaha, Nebraska
USA

Nick Nolte attended Arizona State University on a football scholarship but dropped out to become an actor at the Pasadena Playhouse. He studied at Stella Adler Academy in Los Angeles and traveled for several years, performing in regional theaters. A breakthrough role in the 1976 television series *Rich Man, Poor Man* earned Nolte an Emmy Award nomination, and since then he has played a wide variety of characters in more than fifty films, earning two Academy Award nominations and winning a Golden Globe, as well as a New York Film Critics Circle Award for Best Actor.

Yoko Ono
18 February1933
Tokyo, Kanto
Japan

Yoko Ono moved to New York at
the age of eighteen and gained
notoriety when she opened the
Chambers Street Series in her
loft, where she presented some
of her earliest conceptual and
performance artwork. In 1966,
Ono met John Lennon and they
started their highly publicized
relationship. Ono continues
to create performance and
abstract pieces. Her recent work,
Sky Ladders, was unveiled at
the 2008 Liverpool Biennial.

Jacques Pépin
18 December 1935
Bourg-en-Bresse, Ain
France

One of America's best-known
chefs, Pépin trained in Paris at the
Plaza Athénée. He was chef to
three French heads of state,
including Charles de Gaulle,
before moving to the USA in
1959, where he studied French
literature at Columbia University.
He has published twenty-five
cookbooks and hosted nine
television cooking series, and his
most famous book, *La Technique*,
is considered a seminal text on
the principles of French cuisine. In
2004, Pépin became a Knight of
the National Order of the Legion
of Honour (France).

Rosamunde Pilcher
22 September 1924
Lelant, Cornwall
England

Internationally best-selling author
Rosamunde Pilcher served in the
Women's Royal Naval Service
during World War Two, and the
first of ten novels, written under
the pseudonym Jane Fraser, was
published in 1951. Four years
later, Pilcher began writing under
her own name and international
fame came in 1987 when *The
Shell Seekers* topped the *New
York Times* bestseller list. Several
of her novels have been made
into films and television series. In
2002, she was awarded an OBE
(Order of the British Empire).

Mary Quant
11 February 1934
London
England

Sixties British fashion diva Mary Quant is widely credited with inventing the miniskirt and hot pants. After gaining experience as a milliner, she opened her own shop, Bazaar, on London's King's Road in 1955. Quant began designing her own clothes and by 1961 had a second shop in Knightsbridge. Her internationally famous style was known as "Chelsea Girl," and included the micro-mini, plastic raincoats, and "paint box" make-up. In 1966, she was awarded an OBE (Order of the British Empire) for services to the fashion industry.

Robert Redford
18 August 1937
Santa Monica, California
USA

Robert Redford studied acting at the New York American Academy of Dramatic Arts and debuted on Broadway in 1959. During the 1960s, he appeared in television dramas such as *Alfred Hitchcock Presents* before starring alongside Paul Newman in *Butch Cassidy and the Sundance Kid* in 1969. Many box office hits followed, and in 1980 Redford turned to directing with *Ordinary People,* for which he won an Academy Award for Best Director. In 1980, Redford established the Sundance Institute, which sponsors the annual Sundance Film Festival. In 2002, he received an Academy Lifetime Achievement Award.

Vanessa Redgrave
30 January 1937
London
England

Vanessa Redgrave trained at the Central School of Speech and Drama. She joined the Royal Shakespeare Company in the 1960s, by which time she had already made her film debut and appeared on stage in the West End. She is the recipient of numerous awards, including two Golden Globes and an Academy Award, and in 1967 was awarded a CBE (Commander of the British Empire). Redgrave has supported a number of humanitarian causes since the 1960s and now serves as a UNICEF Goodwill Ambassador.

Richard Rogers
23 July 1933
Florence, Tuscany
Italy

Born to British parents, Richard Rogers studied at the Architectural Association in London and Yale School of Architecture. From 1970–1977 he worked with Italian architect Renzo Piano to create the Pompidou Centre in Paris. His other buildings include the Lloyds building in London (1984), the European Court of Human Rights in Strasburg (1984), the Daimler Chrysler building in Berlin (1999), the Millennium Dome in Greenwich (1999), and Heathrow's Terminal 5 (2008), and he has been chosen as the architect of Tower 3 of the new World Trade Center in New York City. In 1991, Rogers was awarded a KBE (Knight Commander of the British Empire), in 1996 he was made a life peer, and in 2008 he was awarded the Order of the Companions of Honour.

Ravi Shankar
7 April 1920
Varanasi, Uttar Pradesh
India

Ravi Shankar is one of the leading Indian musicians of the modern era. A legend in India and abroad, Shankar has melded Indian music into Western forms: he has written concertos, ballets, and film scores. In the 1960s, Shankar attracted worldwide attention for appearing at the Monterey Pop Festival and Woodstock, and for teaching Beatle George Harrison to play the sitar. His film score for *Gandhi* earned him nominations for both Academy and Grammy awards, and he has received twelve honorary doctorates as well as the Bharat Ratna, India's highest civilian honor. In 1986, he became a member of the Rajya Sabha, India's Upper House of Parliament.

Massimo Vignelli, Lella Vignelli
Massimo 10 January 1931
Milan, Lombardia
Lella 13 August 1934
Udine, Friuli-Venezia Giulia
Italy

Massimo and Lella Vignelli met in Venice while studying architecture. They established the Vignelli Office of Design and Architecture in Milan in 1960, moved to New York in 1966, and founded Vignelli Associates in 1971. They have worked with numerous high-profile companies including IBM, American Airlines, and New York's Metropolitan Transportation Authority, for whom they designed the iconic signage for the New York City subway system. The Vignellis have received multiple awards including the AIGA Gold Medal, and the National Lifetime Achievement Award from the Cooper-Hewitt, National Design Museum in New York. They were inducted into the Interior Design Hall of Fame in 1988.

Andrew Wyeth
12 July 1917 – 16 January 2009
Chadds Ford, Pennsylvania
USA

Andrew Wyeth started drawing
as a young child and was taught
art formally by his father, a well-
known illustrator. He worked
primarily in watercolors and egg
tempera, and his first one-man
show in Maine in 1937, of
watercolors painted around the
family's summer home at Port
Clyde, was the first of many
successes. Wyeth was
considered one of the world's
most collectable living artists,
and, in 1970, became the first
artist to hold a one-man exhibition
at the White House. He was
awarded the Congressional
Medal of Honor (USA) in 1988.

Federico Mayor Zaragoza
1934
Barcelona, Catalonia
Spain

Federico Mayor Zaragoza began
his career as a biochemist after
he obtained a doctorate in
pharmacy from the Complutense
University of Madrid in 1958. In
1974, he co-founded the Severo
Ochoa Centre of Molecular
Biology at the Autonomous
University of Madrid. After many
years spent in politics, Mayor
became Director-General of
UNESCO in 1987, a post he held
until 1999, when he created the
Foundation for a Culture of Peace,
of which he is now the president.
In addition to numerous scientific
publications, Mayor has published
four collections of poems and
several books of essays.

ISBN 978-0-8109-8438-7 (U.S./Canada)
ISBN 978-0-8109-8472-1 (U.K.)

Produced and originated by PQ Blackwell Limited
116 Symonds Street, Auckland, New Zealand
www.pqblackwell.com

Concept and design copyright © 2009 PQ Blackwell Limited
Images, text, and footage copyright © 2009 Andrew Zuckerman
First published in *Wisdom* in 2008

Printed and bound in China

10 9 8 7 6 5 4 3 2 1

Abrams books are available at special discounts when purchased
in quantity for premiums and promotions as well as fundraising
or educational use. Special editions can also be created to speci-
fication. For details, contact specialmarkets@abramsbooks.com
or the address below.

THE ART OF BOOKS SINCE 1949

115 West 18th Street
New York, NY 10011
www.abramsbooks.com

Five percent of the originating publisher's revenue from the sale
of this book will be donated to a *Wisdom* royalty pool that will be
distributed evenly among charities nominated by the individuals
that appear in the book.